J.M.W. TURNER

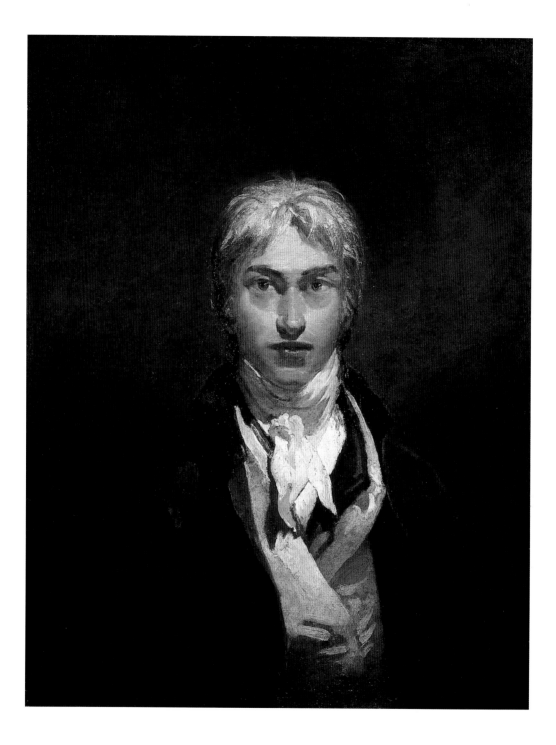

J.M.W. TURNER

Sam Smiles

British Artists

Princeton University Press

To my mother

The image on p.58 is *Fish-Market, Hastings*, 1824, and should appear at the top of p.60; the image on p.60 is *Northampton*, 1830–1, and should appear on p.58.

Front cover: *Snow Storm – Steam-Boat off a Harbour's Mouth Making Signals in Shallow Water and Going by the Lead* 1842 (fig.64, detail)

Back cover: *A Bedroom: A Lady Dressed in Black Standing in a Room with a Green-Curtained Bed – a Figure in the Doorway* 1827 (fig.14, detail)

Frontispiece: *Self-Portrait c.*1799 (fig.10)

Published by order of Tate Trustees by Tate Gallery Publishing Ltd
Millbank, London SW1P 4RG

Published in North America by
Princeton University Press
41 William Street
Princeton, NJ 08540

© Tate Gallery Publishing Ltd 2000

The moral rights of the author have been asserted

ISBN 0-691-07058-x

Library of Congress Catalog
Card Number: 00-103203

Cover design by Slatter-Anderson, London

Concept design James Shurmer
Book design Caroline Johnston

Printed in Hong Kong by South Seas
International Press Ltd

Measurements are given in centimetres, height before width, followed by inches in brackets

CONTENTS

ACKNOWLEDGEMENTS

I would like to thank Richard Humphreys for giving me the opportunity to participate in this series, as well as my editor, Nicola Bion, and picture researcher, Emma Neill, whose support and encouragement smoothed the preparations for publication. Ian Warrell provided a thorough and helpful review of the original manuscript, as did my anonymous reader at Princeton University Press. Their comments have proved immensely valuable and any faults that remain are entirely my own.

Anyone writing on Turner owes an enormous debt to the immense body of scholarly research which has accumulated over the last thirty years. I therefore extend my thanks to the whole community of writers and curators who have done so much to advance our knowledge of Turner; this book is as much theirs as mine, and I hope they will recognise their contributions to the picture drawn here. As always, my family displayed more tolerance of my chaotic working methods than I have any right to expect: I hope the result was worth it. I dedicate this book to my mother, who was kind enough to take me to the great Turner bicentennial exhibition in 1975. It seems to have taken me twenty-five years to thank her properly, but now I can.

1

TURNER'S LEGACY

In a small octagonal room in London's National Gallery hang four works, two by Claude, the French seventeenth-century landscape painter, and two by J.M.W. Turner. One of these pictures is *Dido Building Carthage* (fig.17), whose emulation of Claude's *Seaport* (fig.2) is clearly signified, with a rising sun framed by classical buildings, flooding the scene with light. The other is *Sun Rising through Vapour* (fig.1), first exhibited in 1807, in which Turner pays his debts to the other great landscape tradition in European art, Dutch painting of the golden age. The serenity of the Cuyp-like rising sun, against which are silhouetted boats reminiscent of those painted by van de Cappelle or van de Velde, is contrasted with the genre figures in the foreground, recalling the pictures of Teniers or Ostade, as though Turner wished to incorporate in one image the defining attributes of Netherlandish seventeenth-century art. These comparisons, across countries and centuries, are made possible by an arrangement wholly unlike the rest of the National Gallery's displays, which are otherwise organised by national schools and historical periods. In like manner, a mile or so away, at the Tate Gallery of British Art, the Clore wing sits to one side of the rest of the building, providing a specially designated, reserved environment in which the oil paintings and works on paper of the Turner Bequest can be displayed and studied.

This exceptional treatment at both galleries results from the terms of Turner's will, which stipulated that the works he bequeathed to the nation should be specially housed in 'Turner's Gallery' and that *Dido Building Carthage* and *Sun Rising through Vapour* should hang in perpetuity alongside Claude's *Seaport with the Embarkation of the Queen of Sheba* and *The Mill (Marriage of Isaac and Rebecca)*, respectively. With respect to the National Gallery, it is noteworthy that Turner selected two early works to represent his powers, but it is possible that he believed these pictures to show something of his range, from the genre-like scene of *Sun Rising through Vapour* to the more obviously grand style history painting of *Dido Building Carthage*. Equally, perhaps, just as sunrise in Turner's pictures is associated with the optimistic beginnings of man's endeavours, so here it is fitting that he should have finally chosen two sunrises to stand for his early maturity as an artist. Perhaps, it is even possible that he saw some autobiographical reference here: Turner himself rose from obscurity to throw a new light on the possibility of landscape. Both, however, in their deliberate comparison with the legacy of artistic tradition are marked by a power of natural observation which can make of sunrise two such different phenomena, demonstrating a wider and more knowledgeable understanding of nature than even his great predecessors possessed.

Turner's legacy to his country is, thus, simultaneously an act of generosi-

ty and an attempt to control his reputation even after death, to insist that posterity understand him on his preferred terms. What he seems to be claiming is that his art both invites comparison with the greatest landscape painting of the past and constitutes its own system, a comprehensive vision which can best be understood by keeping its elements together.

It is a moot point whether Turner's will, appropriate to a nineteenth-century understanding of artistic reputation, should still control so much of our experience of his art. Indeed, some would argue that his achievement is at least as well served by incorporating his work among that of his contemporaries rather than hiving it off in a special sanctuary.[1] For no artist was more involved with the culture of his times, using his art to comment on many of the social, political and technological aspects of the modern world. Yet the terms of his will, as regards the disposal of his art, are at the very least indicative of the centrality of his practice to his very being. Pictures were not merely the means to gain a place in society and make a living, allowing a barber's son to amass an estate valued at over five million pounds in 1990s money, they were deeply-considered statements which together proposed a world view. What Turner's will implies is that the truth he had articulated through his practice was too important to be lost.

Turner is probably the greatest painter Britain has produced, and paintings like *The Fighting Temeraire* or *Rain, Steam and Speed* (fig.6) have become

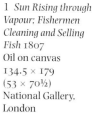

1 *Sun Rising through Vapour; Fishermen Cleaning and Selling Fish* 1807
Oil on canvas
134.5 × 179
(53 × 70½)
National Gallery, London

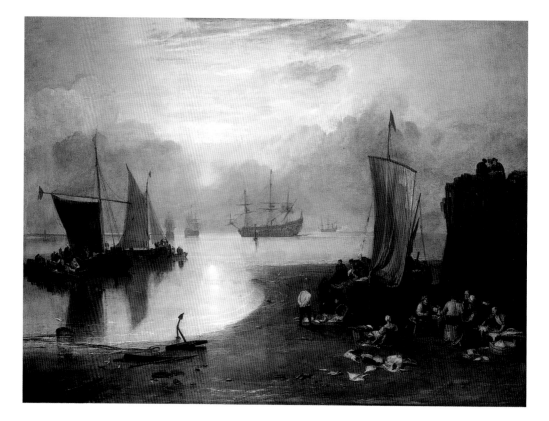

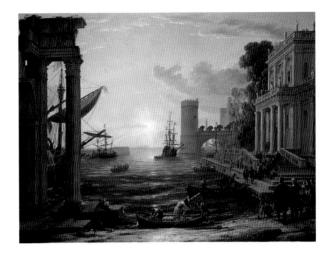

2 Claude,
Seaport with the Embarkation of the Queen of Sheba 1648
Oil on canvas
148.5 × 194
(58½ × 76⅜)
National Gallery,
London

national icons, on a par with Constable's *Hay Wain* or Millais's *Boyhood of Raleigh*. Unlike Constable or Millais, however, Turner's singularity as an artist has bequeathed to posterity a more general appreciation of his art, independent of particular pictures. The notion of 'a Turner sky', usually applied to spectacular sunsets, is widely understood, linking the artist with effects of weather which he alone is deemed to have noticed and celebrated in his art. His position in the world of art criticism seems equally assured. The Turner Prize, organised annually by the Tate Gallery since 1984 to celebrate significant developments in contemporary art, recognises through its title Turner's commitment to artistic excellence and his association with avant-garde practice. In these familiar terms, then, Turner's achievement is understood as primarily a preoccupation with effects of light which, in turn, propelled his practice to the borders of abstraction and thus foreshadowed modernism.

In the modern era, *Norham Castle, Sunrise* (fig. 3) has been seen as somehow typifying this achievement. In the 1975 bicentennial exhibition, Turner's frequent return to the subject was used as the occasion of a retrospective glance at his development.[2] He first visited the spot on a tour to the north of England in 1797 and exhibited a watercolour, *Norham Castle on the Tweed, Summer's Morn*, at the Royal Academy in 1798. A version of the subject was engraved for his landscape treatise, *Liber Studiorum*, in 1816 and Turner returned to the subject in further engravings and watercolours of the 1820s and 1830s. In the late 1830s and 1840s Turner developed some of his *Liber Studiorum* subjects into oil paintings and this picture is presumed to date from then. Its radically abbreviated treatment of the motif, dissolving the castle in sunlight and working the oil-paint as fluidly as watercolour, is, for many, justification enough to consider Turner a great artist.

In that forty-year transition from topographical exactitude to explorations of colour and light, Turner seems to anticipate the development of painting in the modern era. For some, the chief reward of Turner's art is precisely its radical dissolution of form and its anticipation of much that is characteristic

of twentieth-century art. The exhibition *Turner: Imagination and Reality*, held at the Museum of Modern Art, New York, in 1966, might be considered to represent the apogee of this approach. Ninety-nine paintings and water-colours, most of them from Turner's maturity and many of them unfinished (figs.4, 5), helped position Turner at the very heart of all that seemed advanced in modern art, as though in his practice lay the origin of developments leading ultimately to Mark Rothko's evanescent abstract paintings of the 1940s and 1950s.[3]

This, however, is to view Turner with hindsight, as an honourable precursor to Impressionism or the more expressive tendencies in abstract painting, and it is a viewpoint which cannot be critically sustained. For all Turner's masterly abilities to render the most diaphanous expanses of light, to register the full range of atmospheric effects, or to use colour with the utmost subtlety and control, he was always concerned to make his pictures tell. Time and again we find that subject matter is of crucial significance, either as a record of place, or as a historical meditation, and sometimes both together. Equally, colour itself had a value and meaning for Turner derived from long-standing investigations into the nature of perception, colour theory and colour symbolism. *Norham Castle, Sunrise* is unfinished and must therefore represent something of a private statement by Turner, rather than a public communication.

3 *Norham Castle, Sunrise* c.1845
Oil on canvas
91 × 122
(35¾ × 48)
Tate

4 *Venice: Looking Across the Lagoon* 1840
Watercolour 24.4 × 30.4 (9⅝ × 12) Tate

5 *Storm Clouds: Looking out to Sea* 1845
Watercolour 23.8 × 33.6 (9⅜ × 13¼) Tate

But even if Turner had exhibited it in this state, its value would lie not in its approach to what we call abstraction but in its careful attention to colour and light as the building blocks of perception.

At about the same time Turner's finished paintings included work such as *Rain, Steam, and Speed – the Great Western Railway* (fig.6). When it was first exhibited at the Royal Academy, a number of reviewers referred to the 50 miles per hour of the locomotive rushing towards the spectator, as though Turner had managed to paint speed itself.[4] That such an impression could be produced with technical means apparently opposed to naturalism seemed to defy understanding. The handling eschews detail, organising the visual field as a blur of form and colour from which the bridge and train emerge. This effect might be seen as naturalistic, descriptive of rain slanting in from the right, but many of the painted marks are less specific, recording merely an impression of light and landscape. As a critic commented: 'Whether Turner's pictures are dazzling unrealities, or whether they are realities seized upon at a moment's glance, we leave his detractors and admirers to settle between them.'[5]

In the light of works like these it is small wonder that Turner's obituarist in *The Times* felt obliged to characterise his achievement as a sort of poetic magic.

> He loved to deal in the secrets and mysteries of his art, and many of his peculiar effects are produced by means which it would not be easy to discover or to imitate ... He is the Shelley of English painting – the poet and painter both alike veiling their own creations in the dazzling splendour of the imagery with which they are surrounded, mastering every mode of expression, combining scientific labour with an air of negligent profusion, and producing in the end works in which colour and language are but the vestments of poetry.[6]

Yet, from Turner's point of view, the facts of his achievement could be understood easily enough. He once declared that 'the only secret I have got is damned hard work',[7] and the sheer volume of that work is unparalleled. His working career lasted for some sixty years, from the late 1780s to 1851, during which time he produced over 540 oil paintings, exhibiting 238 of them, and close to 1,600 finished watercolours. The contents of his studio, left to the nation and known as the Turner Bequest, included a further 19,300 sketches in sketch-books or on single sheets of paper.

It is equally clear, however, that the 'secret' of Turner's activities might have been more easily revealed had his understanding of art not discouraged easily-gained explanations. His 'damned hard work' had given him the technical facility to communicate complex ideas in paint on an extensive range of subjects, but communication in paint, if painting is to be taken seriously as an activity rather than as a species of illustration, cannot be reduced to any verbal equivalent, as Turner well understood. Turner offered a form of cognition which was mediated through a sensuous form; thought and expression could not be separated.

Those who knew Turner at first hand were quickly aware of his intellect and the power of his mental faculties. On first meeting him, Constable noted,

'I always expected to find him what I did – he is uncouth but has a wonderfull range of mind,' and this was repeated by others who knew him.[8] Francis Palgrave reported: 'The impression Turner made on me was just that of ... great *general* ability and quickness. Whatever subject of talk was started, he seemed master of it – books, politics &c.'[9] Ruskin, who knew him at the end of his life, described his first meeting in similar terms: 'Introduced to-day to the man who beyond all doubt is the greatest of the age; greatest in every faculty of the imagination, in every branch of scenic knowledge; at once *the* painter and poet of the day ... I found in him a somewhat eccentric, keen-mannered, matter-of-fact, English-minded gentleman: good-humoured evidently, bad-tempered evidently, hating humbug of all sorts, shrewd, perhaps a little selfish, highly intellectual, the powers of his mind not brought out with any delight in their manifestation, or intention of display, but flashing out occa-sionally in a word or look.'[10]

The difficulty for those not privileged to meet the artist lay in the seeming obscurity of his art. As his career developed in the 1820s and 1830s, a public reared on a more literal understanding of paintings found it hard to appreci-ate Turner's *modus operandi*. At best, favourable critics might praise the effects of his pictures, even when unable to understand their union with the subject. At worst, his enemies would ridicule his handling, comparing it to a confec-

6 *Rain, Steam, and Speed –The Great Western Railway*
1844
Oil on canvas
91 × 122
(35¾ × 48)
National Gallery, London

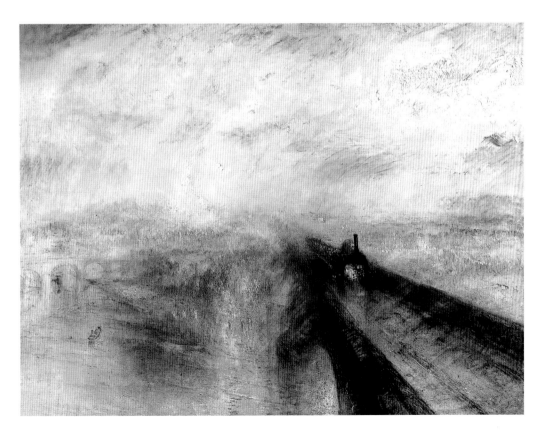

tioner's art, for example, and mock its applicability to the ostensible theme of the painting. Yet, the tendency for critics to concentrate on the means rather than the content of the pictures was precisely due to Turner's insistence that meaning should inhere in the painting. In a manuscript of the 1810s for one of his lectures as Professor of Perspective at the Royal Academy, he declared that '[the] imagination of the artist dwells *enthroned* in his own recess [and] must be incomprehensible as from darkness; and even words fall short of illustration, or become illusory of pictorial appreciations'.[11]

Even those closest to him were never able to get completely straightforward guidance as to the meaning of particular works. His fellow Academician, the landscape painter David Roberts, remembered Turner's interest in keeping things mysterious: 'His life partook of the character of his works; it was mysterious and nothing seemed to please him so much as to try and puzzle you or to make you think so, for if he began to explain, or tell you anything, he was sure to break off in the middle, look very mysterious, nod, and wink his eye, saying to himself "Make that out if you can."'[12] Ruskin, similarly, recalled Turner's approach to his painting *War, the Exile and the Rock Limpet*, exhibited in 1842 (fig.58): '[Turner] tried hard one day for a quarter of an hour to make me guess what he was doing in the picture of Napoleon before it had been exhibited, giving me hint after hint in a rough way; but I could not guess and he would not tell me.'[13]

Given Turner's reticence, it has been the task of modern scholarship, especially over the last thirty years, to speak for him. Like all attempts at historical retrieval this project is fraught with difficulties. Few art historians would accept that an objective account of the past is possible and many would be wary of any attempt to discount 'uninformed' appreciation of Turner as worthless, just because it differs from what his intentions may have been, assuming that we could discover them in the first place. Works of art accrue interpretations and meanings like a patina and too vigorous an historical cleaning may prove detrimental to their continuing vitality. There is an equal recognition that subsequent generations of scholars and art-lovers will make of his achievement what they will and the Turner understood in the twenty-first century will inevitably betray twenty-first century concerns.

That said, a fuller examination of manuscript sources, technical research into pigments and papers, the compilation of *catalogues raisonnés* of his oils, watercolours and engravings, together with wide-ranging inquiries into different aspects of his artistic and theoretical practice have all helped to provide a more ample fund of information with which to retrieve the meaning of his art from critical misconstruings. These understandings have moved on from the idea of Turner as primarily a recorder of light and landscape, to consider his responses to the social and intellectual climate of his times. The Turner that emerges from such investigations is no less prodigious a phenomenon; but his complex artistic personality has now emerged more fully from behind the work.

Turner lived long enough to witness the advent of photography, which fascinated him, to see the construction of the Crystal Palace for the Great Exhibition and for his last exhibited works at the Royal Academy to overlap the

first Pre-Raphaelite paintings exhibited there. Necessarily, given such a long creative life, we tend to regard him as primarily a nineteenth-century artist, but he was twenty-five at the turn of the century and had entered the Royal Academy Schools when Sir Joshua Reynolds was still President. To some extent, much of his achievement might be regarded as elaborating ideas and experiences from this formative time, renovating and extending them in the circumstances of the new century. Unlike his contemporary John Constable (1776–1837), who was prepared to rest his main claim for fame on pictures of unassuming landscape, albeit imbued with sentiment and achieved by technical bravado, Turner might be seen as carrying on a tradition associated with his great eighteenth-century predecessor, Richard Wilson (1713–82), whose landscapes invoked classical myth and history, as well as more naturalistic studies. And, just as Wilson had manipulated landscape to articulate a nuanced sense of place, whose understanding was based on shared assumptions concerning society and the common weal, so Turner used landscape as a vehicle for the profoundest ruminations on society, politics and the human condition, not least the clash of contemporary empires and the dangers of corruption for the body politic.

The idea that art might contribute to thinking about the course of history, the development of human society or the prospects for man's improvement seems impossibly grandiloquent in the early Victorian art world, whose narrower conception of a public art put more emphasis on documentary realism, or at its worst a prosaic literalism inimical to a poetic imagination like Turner's. Indeed, it might be argued that Turner's art represents the last time that creativity was put at the service of the public rather than being driven in on itself. It is one of the ironies of history that Turner's public art was increasingly misunderstood as little more than a wayward private fantasy.

Yet, for all his affinities with the moral seriousness of eighteenth-century art, Turner's technical means far outstripped his contemporaries and his successors. Although he could be negligent of preparation and, towards the end of his life, seemingly indifferent to the conservation of his paintings, as a painter he produced effects which lay beyond the competence of any other artist. More importantly, perhaps, his imaginative reach gave full occasion for the deployment of his abilities not merely to record the surface appearance of the world but to comprehend it as a complex of interconnected qualities, natural and man-made, noble and ignoble, moral and rational. The formal means needed to encompass such a vision were necessarily extremely sophisticated and, on occasion, uncompromising. For modern viewers, it is precisely this combination of supreme artistic ability and personal integrity that makes Turner's paintings so compelling.

2

THE MAKING OF AN ARTIST

As a young man Turner's earliest experiences in art were limited and he was essentially self-taught as an artist. That he had facility his father did not doubt, and apparently showed examples of his son's work in the window of his barbershop in Maiden Lane, Covent Garden. From about 1786, aged eleven, Turner gained some experience in colouring antiquarian engravings at his uncle's in Brentford, where he went to school, and he received a certain amount of instruction in the architectural drawing-office of Thomas Malton and from the watercolour artist Edward Dayes. He was admitted as a probationer to the Royal Academy Schools in December 1789, studying first in the Cast Academy for three years and then in the Life Class between 1792 and 1797. These early experiences were sufficiently instructive to enable him to win the Society of Arts prize for landscape drawing in March 1793. More fortuitously, from about 1794 to 1797 he joined the circle of young artists who met at the house of the physician and amateur Thomas Monro, to copy and colour drawings in his collection. Here Turner met Thomas Girtin (1775–1802), his contemporary and, for some, his early rival in the development of watercolour painting.

As a medium, watercolour was widely used to produce topographical and antiquarian drawings, suitable for engraving, and was the staple mode of instruction employed by drawing masters, tuition which Turner himself provided between 1794 and 1797, but it had yet to achieve any sort of parity with oil painting, which was still considered to be uniquely capable of engaging with the highest creative capabilities of the human mind. Girtin and Turner are traditionally regarded as the two artists who developed the expressive potential of watercolour such that it might vie with oils as a serious medium.

Turner's first exhibited work was a watercolour at the Royal Academy in 1790 and it was not until 1796 that he showed his first oil. His watercolours exhibited in 1794 first attracted press notice, with favourable comments on his precision of detail and truth to nature. His growing proficiency and critical respect attracted a good deal of patronage as witnessed by three examples from the late 1790s: Sir Richard Colt Hoare, of Stourhead in Wiltshire, commissioned two watercolours of Salisbury Cathedral, the first of nearly thirty drawings; William Beckford invited him for a three-week stay at Fonthill in 1799 making studies of his new Gothic extravaganza, five of which were exhibited at the Royal Academy in 1800, and Turner was recommended to the Earl of Elgin to accompany his expedition to Athens, from which the Parthenon sculptures would eventually be shipped to London. Turner declined this last commission because he could not agree terms, although it is

possible that his real motive was to avoid being pigeon-holed as an architectural and antiquarian draughtsman.

Had he accepted Elgin's commission he would have left England for the first time. As it was, the outbreak of war with France in 1793 had made continental touring extremely hazardous. In its place, tourism flourished within the British Isles, exploiting the picturesque attractions of the local landscape, especially Wales and the river Wye, the Lake District, and Scotland. In part this was occasioned by necessity, the impulse to tour abroad having to turn inward, but it also helped to construct a sense of national identity and to buttress patriotic feelings as the historic legacy and scenic charms of Britain were reappraised. Topographical images, whether watercolours or prints, helped the nation to begin to know itself for the first time and artists were in demand to supply this growing market. Turner himself began to tour in the 1790s, visiting Bristol, Bath and Malmsebury in the summer of 1791, Wales in 1792, the Midlands in 1794, South Wales and the Isle of Wight in 1795, the north of England in 1797, and Wales again in 1798 and 1799.

It is important to note that Turner's exhibited watercolours were produced in the studio, not from the motif. When touring, Turner carried pocket-sized sketchbooks, which he would fill with pencil drawings and memoranda, occasionally working across both pages, or, alternatively, subdividing a page to record different aspects. Written colour notes might be added but actual colour studies were rarely made. As Ruskin later observed of Turner's avoidance of colour sketching: 'before the deliberate processes necessary to secure the true colours could be got through, the effect would have changed twenty times over. He therefore almost always wrote the colours down in words, and laid in the effect at home.'[1] When based in one place for a more protracted campaign Turner also made use of larger sketchbooks, which sometimes

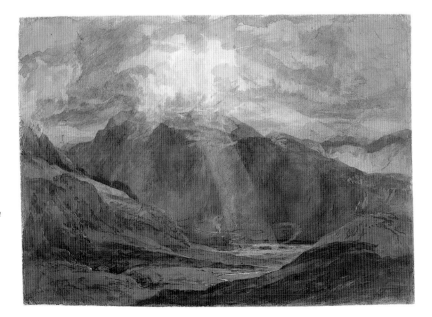

7 Nant Ffrancon from above Llanllechyd
1799–1800
Pencil and
watercolour
55.3 × 77.2
(21¾ × 30⅜)
Tate

17

include colour sketches alongside pencil studies. Many of these would have been worked up away from the motif but equally, some of these colour sketches evidently result from Turner working in the open air and some tours of the 1790s and early 1800s contain colour studies made on the spot.[2]

If sketching from the motif provided a store of visual data, work in the studio provided an opportunity for technical experimentation when the original stimulus was reworked and developed to unlock its potential as a subject. In distinguishing finished works from their originating sketches, Turner was indebted to eighteenth-century academic training. In one of his lecture manuscripts of the 1810s he paraphrased Reynolds, recommending that his students 'mark the greater from the lesser truth; namely the larger and more liberal idea of nature from the comparatively narrow and confined ... that which addresses itself to the imagination from that which is solely addressed to the Eye'.[3] Sketching for Turner was therefore a means of training the eye and developing the imagination, and from the outset of his career he was aware of the need to produce a creative response to the motif rather than merely recording it. His work in the open air was thus solely a means of gathering raw material for subsequent transformation in the studio into works of art. A series of studies would be produced, refining the composition before one design was taken forward for completion with the level of finish necessary for exhibition, sale or engraving.

Joseph Farington, himself a topographical landscape painter and a member of the Royal Academy, recorded in his diary a number of meetings with the young artist. In 1799 he noted that Turner deprecated the more mechanical approaches to painting in watercolours which some practitioners had reduced to a systematic procedure. 'He thinks it can produce nothing but manner and sameness ... Turner has no settled process but drives the colours abt. till He has expressed the idea in his mind.'[4] Something of that creative expression can be seen in the larger watercolours produced on his Welsh tours. Although some may have been made largely in front of the motif, others, such as this view of *Nant Ffrancon* (fig.7) produced in the studio, seem to exemplify the expressive benefits of driving the colours about, as explained to Farington.

Studies like *Nant Ffrancon* need to be distinguished, in turn, from finished watercolours. A good example of the same period is provided by *The Trancept of Ewenny Priory, Glamorganshire* (fig.8), exhibited at the Royal Academy in 1797, and derived from pencil sketches made on Turner's trip to south Wales two years earlier. The dramatic use of chiaroscuro may have been influenced by the architectural drawings of Piranesi, and one contemporary reviewer was moved to consider it as equal to the best pictures of Rembrandt for its effect. Certainly, the use of three light sources – the large window at the left, the smaller windows and doorway on the right – allows Turner to demonstrate a nice discrimination between different sorts of illumination, which in turn articulates the interior space as a visual complex formed by light. The careful attention to detail of farmyard implements and livestock helps provide a certain poignancy to the image, witnessing the decline from the Priory's original ecclesiastical splendour to mundane modern usage. This comparison

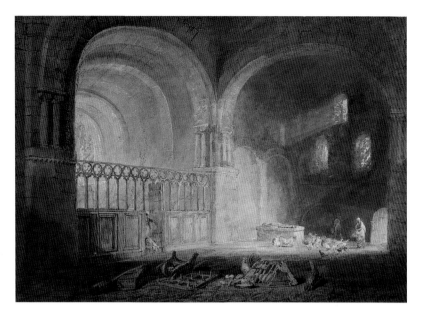

8 *The Trancept of Ewenny Priory, Glamorganshire* 1797
Watercolour
40 × 55.9
(15¾ × 22)
National Museum of Wales, Cardiff

is emphasised by the tomb of Moris de Londes, carefully recorded in Turner's sketchbook, bathed in light next to some feeding chickens. Plainly, from a topographical point of view, this watercolour is conceived less to provide detailed information of architecture and church furnishings and more to provide an aesthetic experience normally associated with high art.

A picture originating from his 1797 tour to northern England exemplifies another way in which Turner chose to extend the meaning of landscape painting. In 1798 the Royal Academy altered its exhibition procedures, allowing artists to include verses in the catalogue to accompany their pictures. Turner took immediate advantage of this arrangement and added verses from John Milton's *Paradise Lost* or James Thomson's *Seasons* to five of that year's exhibits. *Morning amongst the Coniston Fells* (fig.9), an oil-painting exhibited in 1798, was accompanied by an extract from *Paradise Lost*, describing the sun rising among mist-shrouded hills and lakes. Although it was praised for its naturalism, at a time when many in the Royal Academy were obsessed with artificial experiments to recover the secrets of the Renaissance, others were less convinced. The portrait painter John Hoppner described Turner's exhibits this year as those of 'a timid man afraid to venture,'[5] presumably reacting to the treatment of the landscape, necessarily undifferentiated here in its representation of the low tonality of dawn.

If Turner was afraid to venture in 1798, his use of poetry might be seen as attempting quite the reverse, to enlarge his sphere of operation. Turner's attitude to poetry was that its discursive treatment of a topic, using landscape imagery metaphorically to link ideas in extended chains, would help liberate landscape from a merely topographical register. In a manuscript written in about 1810 he declared: 'Painting and Poetry flowing from the same fount ...

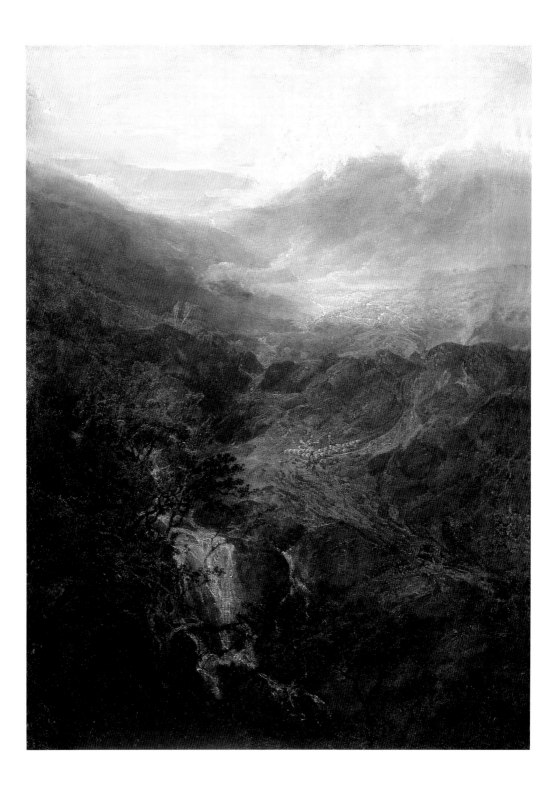

9 *Morning amongst the Coniston Fells, Cumberland* 1798
Oil on canvas 123 × 89.7 (48⅜ × 35¼) Tate

reflect and refract each others beauties with reciprocity of splendorous allusion.'[6] Milton and Thomson remained early favourites of the artist and other poets were pressed into service, too: among them, Thomas Gray, Alexander Pope, Mark Akenside and English translations of classical poetry. Turner's respect for eighteenth-century poetry was made evident in his early maturity when he exhibited two paintings honouring its achievement: *Pope's Villa at Twickenham during its Dilapidation* (fig.19) and *Thomson's Aeolian Harp* (1809). Among contemporary poets, Byron's *Childe Harold* was referred to on a number of occasions from 1818, not least in 1832 and 1835 when Turner exhibited paintings whose titles alluded directly to that poem. In 1800 and 1809 some of his pictures were exhibited with verses which are probably his own. What is of greater significance, however, is that starting in 1812, he began regularly to include quotations from his poem, *Fallacies of Hope*, presumably because his subjects could no longer find an adequate correlative in the works of extant poets. Extracts from this poem continued to appear up to his last exhibits at the Royal Academy in 1850.

Success came early. He was made an Associate of the Royal Academy in 1799, at the youngest possible age, and became a full Academician in 1802, at the early age of twenty-seven. Turner's self-portrait (fig.10) dates from about this time, showing the young artist, in his early twenties, fashionably-dressed. As far as is known, he never painted another portrait after this. The private Turner, his relationships with women, his two illegitimate children, his secret homes and aliases, would become a thing of increasing mystery, at the end of his life unknown to practically all his acquaintances. The work, exhibited to the public year in year out, was the place in which his character and beliefs were properly on display.

Turner's studies in the Academy Schools had equipped him, both in this picture and in some nude studies, to produce capable treatments of the human form and physiognomy. He later served as Visitor in the Life Academy on eight occasions between 1812 and 1838, introducing teaching methods which the students found extremely effective. All of this activity suggests that the awkwardness of the cursory, doll-like figures who inhabit much of his mature art was not entirely a matter of artistic ineptitude; instead we might surmise that Turner's understanding of pictorial harmony required this abbreviated treatment of figures if they were to be integrated into the linear and chromatic structure of a picture. This is not to claim that the staffage figures are incidental, however, for they often have pivotal roles to play in guiding the interpretation of a painting. It is rather that Turner needed his figures to be understood within the overall composition, as opposed to calling attention to themselves independently of their surroundings.

In 1799, consolidating his new-won status, Turner moved to a more fashionable part of London, taking rooms at 64 Harley Street. In 1804 he had a picture gallery constructed behind this house, where he showed his work until 1816. Between 1816 and 1822 he enlarged his premises and constructed a new gallery to his own designs, with a frontage in Queen Anne Street, around the corner from no. 64. For established artists a private gallery was not necessarily unusual in this period, but for a relative newcomer this was almost a pre-

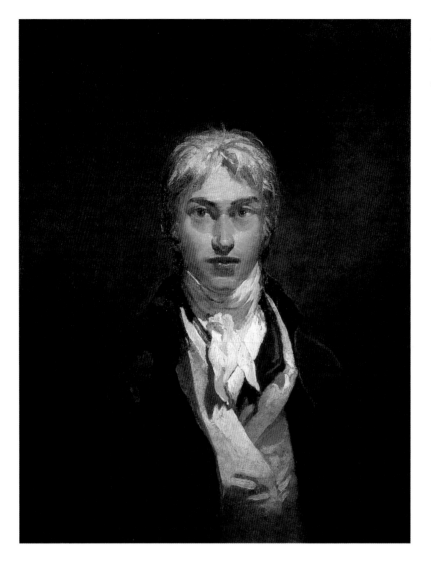

10 *Self-Portrait*
*c.*1799
Oil on canvas
74.5 × 58.5
(29⅜ × 23)
Tate

sumptuous move. It clearly indicates how Turner, two years after his election to the Royal Academy and still only twenty-nine, was prepared to declare his independence. Although he still exhibited at the Royal Academy, and occasionally elsewhere, in Queen Anne Street he could show his paintings to their best effect, free of the competitive nature of public exhibitions and in a purpose-built space, designed by an artist with architectural training. (In 1813 he erected a house of his own design, too: Solus or Sandycombe Lodge, at Twickenham.) The second gallery had walls clad in Indian Red and used top-lighting, diffused by means of a herring-net, with sheets of tissue paper spread on it, slung across the room just above the walls. About twenty-four to twenty-eight finished canvases were typically exhibited, hung frame to frame as at the Royal Academy, with recent paintings displayed on easels.

Some of the impetus to create a gallery of his own may have come from his experience of the Louvre in 1802. The treaty of Amiens produced a temporary truce with France, allowing foreign travel for the first time in nine years. Turner visited France and Switzerland between July and October, travelling in some style. Napoleon's looting of works of art for display in the Louvre made Paris a magnet for English artists. It is important to remember that no public collection of works of art yet existed in Britain, and although access to some of the great private collections was regularly granted, the lack of a major public collection was keenly felt. The collections amassed in the Louvre therefore offered an outstanding and, at this date, unique opportunity to study the whole history of European art. Although the collection amply repaid his expectations, Turner was struck by the inadequacy of the display, which made viewing pictures extremely difficult. His own gallery would be specifically designed to overcome such problems.

He spent about a fortnight in Paris making notes on the works of the old masters and the modern French school, including a visit to the studio of Jacques Louis David, the dominant force in French painting since the 1780s, politically allied with Robespierre and the regicides in the 1790s and now Napoleon's chief painter. Here Turner saw David's *Napoleon on the St Bernard Pass*, which showed Napoleon as a latter-day Hannibal, commemorating his feat of taking an army across the Alps into Italy. Like many English artists, Turner criticised the modern French school for its overemphasis on drawing. Reminiscing in 1809, he declared that the French 'look with cool indifference at all the matchless power of Titian's glowing tones, because precision of detail is their sole idol'.[7]

His first encounter with Switzerland was equally important to him. Still in political ferment as a result of Napoleon's campaigns, many of its locations had been the site of recent bloody battles. Travel through the region was physically tough, requiring hazardous journeys on mule-back and, when that was impossible, on foot. Turner captured the awesome nature of this experience in a large watercolour, *The Passage of Mount St Gothard, taken from the centre of the Teufels Bruch (Devil's Bridge) Switzerland* (fig.11), which was shown at the inaugural exhibition of his own gallery in 1804. The title's reminder that this view is taken from the bridge itself would have registered at the time, as the force of the wind, funnelled through the rocky chasm of the St Gotthard, sometimes caused travellers to crawl rather than walk across the span. In choosing a vertical format, Turner has emphasised the vertiginous drop into the abyss below, as clouds roll in ominously from up ahead. The ambition of this image is matched by its size, driving up watercolour to compete with oil painting. The watercolour was bought by the Yorkshire MP Walter Fawkes (1769–1825), who had travelled in Switzerland himself and must have understood Turner's intentions. He ordered further Swiss watercolours from subjects in Turner's sketchbooks and extended his patronage in subsequent years, building up an extensive collection of watercolours, as well as some oils. Fawkes was to become Turner's most significant patron, and a very close friend. Turner visited Farnley Hall, Fawkes's family home in Yorkshire, in 1809 and spent time there most years until 1824.

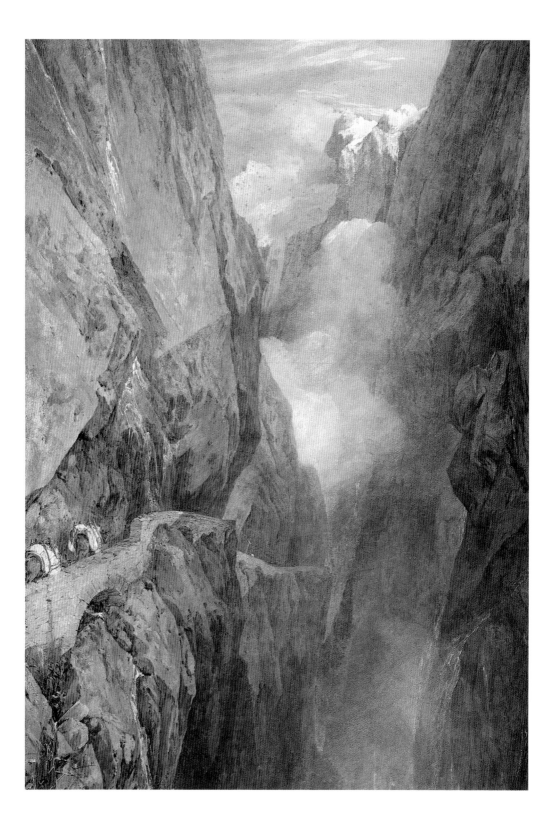

The 1802 trip can be seen as pivotal in Turner's development. On the one hand, his experiences in Switzerland decisively affected his comprehension of landscape; on the other, his studies in the Louvre nourished that tendency to emulate, if not actually surpass, the old masters. He had already begun to receive much praise, but also some criticism, for his allusions to other painters in his exhibits at the Royal Academy. *The Fifth Plague of Egypt* (fig.12) (actually a misnomer, as this shows the seventh plague, of hail and fire) provokes comparisons with artistic traditions. An exercise in grand style painting, and Turner's largest canvas to date, it was an early triumph for him, and widely praised at the Royal Academy for its grandeur of conception. In its melding of history and landscape painting, it shows Turner's desire to go beyond his great English predecessor, the landscape painter Richard Wilson, and even, in its organisation of space and its sublime emotion, to emulate the French seventeenth-century painter Nicolas Poussin. The tempestuous sky may owe something to the dramatic weather recorded in Turner's Welsh tours. William Beckford bought the picture, to hang in Fonthill alongside his paintings by Claude, pictures which Turner only a few years earlier had claimed he would never be able to rival.

Dutch marine painting of the seventeenth century also inspired him. *Ships Bearing up for Anchorage* (fig.13) is a good example of the kind of picture that made Turner's name, although it was little noticed when first exhibited at the Royal Academy in 1802. A year earlier he had exhibited another marine, *Dutch Boats in a Gale* (known as *The Bridgwater Seapiece*), which was the

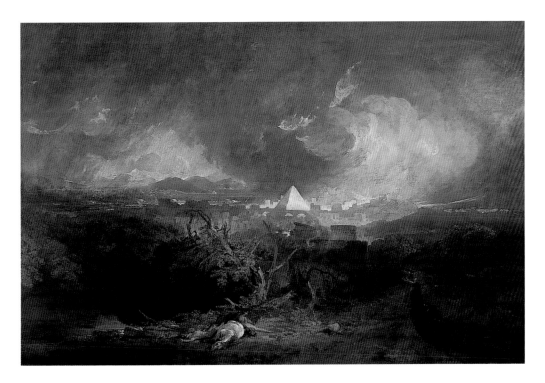

picture of the year at the RA, widely admired by his fellow artists and the general public, even though its critical reception included remarks warning against too great a freedom in the application of paint. Turner's response with this picture seems to have been to go even further towards loosening his practice, demonstrating complete control in rendering the choppy water and squally weather. The picture was bought by the Third Earl of Egremont, the owner of Petworth House in Sussex, and is known today as *The Egremont Sea-piece*. Egremont (1751–1837) was to become another of Turner's most important patrons, owning fifteen works by 1813, and Turner was a regular visitor at Petworth in the 1820s and 1830s, using the Old Library as his studio and producing a series of over a hundred gouaches of the intimate life of the household (fig.14).

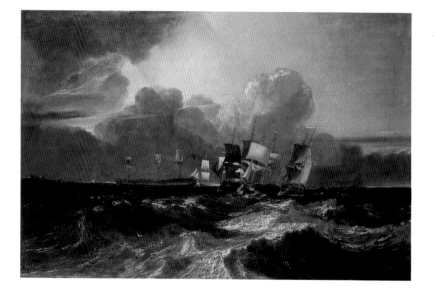

13 *Ships Bearing up for Anchorage (The Egremont Seapiece)*
1802
Oil on canvas
119.5 × 180.3
(47 × 71)
Petworth House

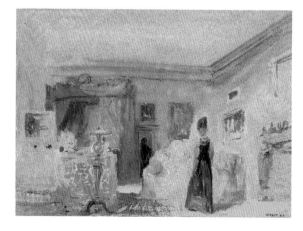

14 *A Bedroom: A Lady Dressed in Black Standing in a Room with a Green-Curtained Bed – a Figure in the Doorway* 1827
Watercolour
13.8 × 19.2
(5⅜ × 7½)
Tate

3

PAINTING AND MEANING

The years after 1805 mark a shift in Turner's development towards a more determinedly didactic tendency. In the autumn of 1806 he was staying with his friend, William Frederick Wells, at Knockholt in Kent, where the initial plans for the *Liber Studiorum* were laid (fig.15). The idea was to publish a part-work containing a series of etchings which would demonstrate the range of Turner's abilities in landscape. Each plate was given a letter code, distinguishing it as A: Architectural, P: Pastoral, M: Marine, H: Historical, MS: Mountainous, and EP: not explained, but probably Elevated or Epic Pastoral. Fourteen parts, comprising seventy-one plates in total, were issued between 1807 and 1819. (A further twenty plates were engraved but not published.) The *Liber Studiorum* is best considered as a landscape treatise, even though it contains no letterpress. Although its most immediate function was to disseminate Turner's powers to a wider public, its systematic treatment of landscape as a genre with an extensive range had the additional purpose of underscoring the importance of landscape for modern art. Conventionally, academic theory had reserved the highest praise for history painting, which is to say images derived from classical history and mythology, national history or the Bible. Landscape, casually understood as merely the record of a given spot, seemed to offer little potential for the creative imagination in its execution, nor

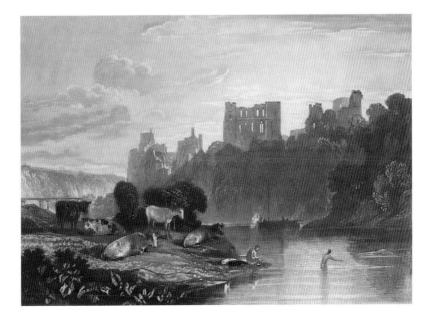

15 J.M.W. Turner,
etching, and W.
Annis, mezzotint,
'River Wye' 1812,
from *Liber Studiorum*
18.4 × 26.5
(7¼ × 10⅜)
Tate

for the arousal of profound emotions in its spectators. As we have seen, Turner's artistic practice had already begun to challenge such assumptions, repositioning landscape as fully capable of competing with history painting. Now, in the *Liber Studiorum*, he could demonstrate how his expansive understanding of landscape incorporated much that history painting had considered its unique preserve.

This didactic impulse was confirmed in 1807 when Turner put himself forward as the Royal Academy's Professor of Perspective. Like the *Liber Studiorum*, much of what he wanted to demonstrate in his lectures was achieved by means of images, in this case specially prepared diagrams whose beauty was, for some, the main reason to attend (fig.16). The manuscripts of these lectures, first given in 1811, reveal that Turner used the occasion not only to talk about perspective, but also to offer insights into art practice and the history of art. He was concerned to examine the origin of habits of perception, and the relations between perception and the world, themes that might equally be said to propel the development of his mature practice as a painter. He was also concerned to show that schematic, rule-bound precepts inevitably over-simplified art, arguing instead for guidance based in practical experience. This suspicion of doctrinaire theory echoes his dissatisfaction with mechanical watercolour practice discussed with Farington in 1799.

Some of his paintings of these years also seem more obviously concerned to instruct. In *Dido Building Carthage; or the Rise of the Carthaginian Empire* (fig.17) we see Turner's ability to bring together in one picture a range of meanings which together demonstrate the powers of landscape to arrogate to itself the potential customarily reserved for history painting. The picture shows Dido, Queen of Carthage, on the left, supervising her architects. The city rises into the morning light, while at the water's edge a group of boys launch toy galleys into the water, pushed towards the spectator by the incoming tide. These details suggest a mood of optimism and hope for the future: Dido's plans are set fair. Turner added a subtitle, '1st book of Virgil's Æneid', to the Royal Academy exhibition catalogue to remind his viewers of the classical narrative: how Aeneas, fleeing the city of Troy after its destruction by the

16 *Interior of a Prison*, Perspective Diagram *c.*1810
Pencil, watercolour and bodycolour
48.7 × 68.7
(19⅛ × 27)
Tate

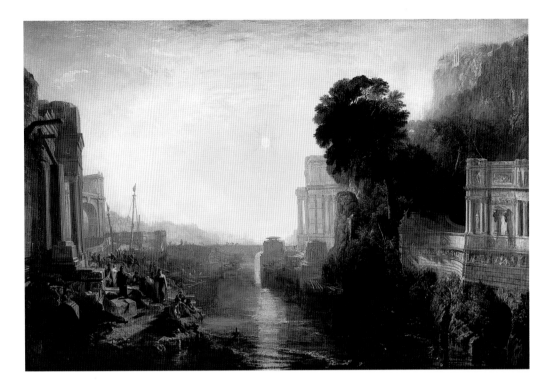

17 *Dido Building Carthage; or the Rise of the Carthaginian Empire* 1815
Oil on canvas
155.5 × 232
(61¼ × 91⅜)
National Gallery, London

Greeks, fetched up on the North African coast and became Dido's lover, before being ordered to leave by the Gods to fulfil his destiny as founder of Rome. His departure caused Dido to kill herself in despair and to swear eternal enmity between Carthage and Rome. The story thus sets out the mythical beginnings of a historical conflict, played out in the three Punic Wars, which ended with Carthage's total obliteration. Knowledge of this outcome gives this optimistic scene a tragic undercurrent and a sense of proleptic irony that all of Dido's endeavours will end in ruin. The picture is clearly indebted to Turner's illustrious predecessor in landscape painting, Claude Lorrain, and, as we have seen, was one of the two pictures Turner stipulated in his will to hang alongside works by Claude in the National Gallery (p.7). But, arguably, Turner's picture is more ambitious than Claude's *Seaport*, for he brings together three registers of meaning in one image: the symbolic rising sun to signify the dawn of empire, the mythical Dido and the historical Carthage.

The struggle between Rome and Carthage was of topical interest in the 1810s, as it seemed to prefigure contemporary hostilities between Britain and France. Naturally, both British and French authors could demonstrate their own country to be closer to victorious Rome than defeated Carthage, but Turner does not seem to have intended such a one-to-one identification, preferring to ruminate more generally on the course of empire and the evils that beset it. Three years earlier he had exhibited another picture with a Carthaginian theme, *Snow Storm: Hannibal and his Army Crossing the Alps* (fig.18). This was the first of Turner's pictures to be exhibited with accompa-

nying lines from his poem *Fallacies of Hope*, and the verses are a good example of the complexity of Turner's intentions:

> Craft, treachery and fraud – Salassian force,
> Hung on the fainting rear! then Plunder seiz'd
> The victor and the captive, Saguntum's spoil,
> Alike, became their prey; still the chief advanc'd,
> Look'd on the sun with hope; – low, broad, and wan;
> While the fierce archer of the downward year
> Stains Italy's blanch'd barrier with storms.
> In vain each pass, ensanguin'd deep with dead,
> Or rocky fragments, wide destruction roll'd.
> Still on Campania's fertile plains – he thought,
> But the loud breeze sob'd, 'Capua's joys beware!'

18 *Snow Storm: Hannibal and his Army Crossing the Alps* 1812
Oil on canvas
146 × 237.5
(57½ × 93½)
Tate

Hannibal's troops, near the end of their epic march through the Alps, move forwards into the eerie light of a sun whose strength is nearly eclipsed in a welter of dark clouds, swirling around it. The storm bursting on the scene at the right hurls snow and ice at the Carthaginians, as deadly as the rock slides being organised against them by native Swiss tribesmen in the centre. To the left and in the foreground, the slaughter of the baggage train's defenders is brutally depicted. Hannibal himself, one presumes, his elephants silhouetted in the far distance, is in the van of the army heedless of the assault overwhelming his rearguard. For Turner, one of the greatest military feats of all time is seen not as a triumph, but as the first act of a tragedy, begotten in storm and blood, whose issue will be defeat and destruction. Italy, the goal Hannibal so ardently desires, will be the Carthaginians' undoing, succumbing to soft living and forgetting their purpose. The fury of the storm is thus counterpoised not with a sun symbolic of hope, but with the false light of delusion.

Turner's general attitude to meaning is worth considering here. We have already noted Ruskin and others' frustration at his refusal to clarify his intentions and we have valuable evidence that he favoured an elliptical approach. In 1811, the antiquarian and topographical author John Britton intended including an engraving of Turner's *Pope's Villa at Twickenham during its Dilapidation* (fig.19) in his publication, the *Fine Arts of the English School*. The painting was owned by another of Turner's significant early patrons, Sir John Leicester (1762–1827), a noted collector of contemporary English art. *Pope's Villa* is essentially a witness of neglect, occasioned by the demolition of Pope's old residence in 1807 to make way for a new house, thus making a wider point about the ephemeral nature of fame or reputation. Turner's comments on the letterpress to accompany the engraving are interesting in his avoidance of literal or obviously symbolic meanings; he preferred to work more suggestively: '... making the willow tree the identical Pope's willow is rather strained – cannot you do it by allusion?'[1] As we shall see, there are occasions when Turner's symbolic imagery is direct and easily understood, but more often than not his allusions to ideas do not give themselves up at first glance, requiring instead a commitment from the spectator to engage with the work with full attention. This is serious art, requiring serious consideration.

19 *Pope's Villa at Twickenham during its Dilapidation* 1808
Oil on canvas
91.5 × 120.6
(36 × 47½)
The Trustees of the Walter Morrison Picture Settlement

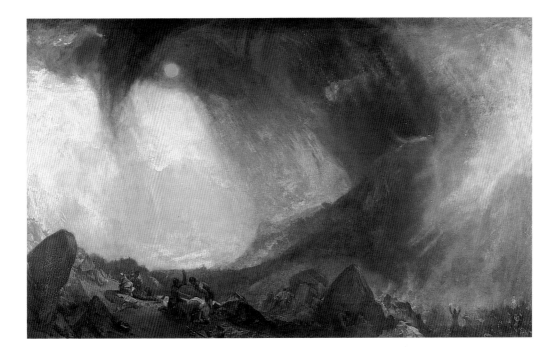

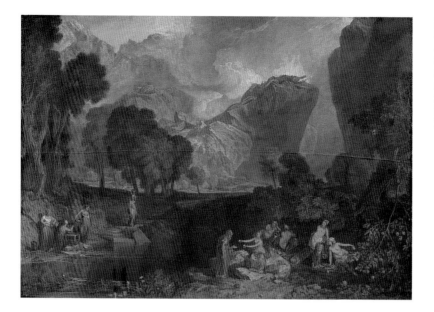

20 *The Goddess of
Discord Choosing the
Apple of Contention in
the Garden of the
Hesperides* 1806
Oil on canvas
155 × 218.5
(61 × 86)
Tate

Dido Building Carthage and *Hannibal* both suggest a tragic view of history. If Turner's meditation on the human condition was ultimately pessimistic, an early clue to that philosophy is provided by *The Goddess of Discord Choosing the Apple of Contention* (fig.20). The story comes from Greek mythology, relating how Discord gate-crashed the bridal feast of Peleus and Thetis and claimed the apple of contention as a gift, the same apple which would later be awarded by Paris to the fairest of the gods, a decision which in its turn would cause the Trojan War. Like Eve's tasting of the forbidden fruit, so here, the baleful influence of discord will echo down the generations of human history, leaving havoc and misery in its wake. Behind this narrative, other symbolic possibilities are set in play by Turner's syncretic use of mythology. In his contemporary verse-sketch 'Ode to Discord', Turner gives the bridal feast to Psyche, and in doing so may have been attempting to stage the picture as an alchemical allegory, using the traditional associations of each of the protagonists with one of the elements (earth, air, fire, water) to oppose light and darkness, material and immaterial substance.[2] If so, this was an arcane purpose which only a few initiates could have been expected to divine. He may have realised that such complex iconography could not deliver the result he intended for, although other classical subjects of this period are also susceptible to such intricate readings, Turner moved away from such possibilities in the 1810s and afterwards. Yet, for all that, it can be argued that his fundamental insight into the operations of light and colour as registers of almost cosmic significance never deserted him and that in his last decade as a painter, especially, these concerns returned, purged of this programmatic symbolism, and vested now in an entirely chromatic understanding.

What is abundantly clear, however, is that the truth of painting mattered more than any sort of documentary illustration. We have already noted how

Turner's sketching procedure took studies from the motif as starting points for imaginative exploration, and an anecdote associated with a picture of the 1820s reinforces the point. The pictures resulting from his first trip to Italy in 1819 included one, *The Bay of Baiae, with Apollo and the Sibyl* (fig.21), which definitely eschews documentation for the sake of imagination. The painting shows an incident from Ovid's *Metamorphoses* which relates how Deiphobe, the Cumaean Sibyl, was loved by Apollo, who promised to grant her any wish. She picked up a handful of dust and asked to live one year for each grain of it, but refused Apollo's offer of perpetual youth in return for loving him. She thus aged into a long decrepitude until only her voice remained. Baiae itself was known in Roman times for its decadence, so Deiphobe and Baiae together come to stand for the fall of Rome, whose imperial glory was followed by a long decline into mouldering ruin. Turner's sumptuous colour was censured by critics for its non-naturalistic appearance, and his friend, the artist George Jones, knowing that Turner's Baiae was largely his invention rather than topographically exact, wrote 'Splendide Mendax' (Gloriously False) on the frame. Turner never removed the inscription and in a good-humoured reply told Jones that what he had painted was all there and that all poets were liars.[3] In saying so, he seems to have acknowledged what his more supportive critics were declaring, that the truth of his art did not lie in its relationship to any prosaic reality but, rather, in his ability as an artist to use invention as a means towards discovering deeper understandings of the world. As we shall see, however, for Turner this did not mean abandoning reality for flights of fancy; indeed, his art remained obstinately rooted in material reality and observation, even when its effects seem far removed from the everyday.

21 *The Bay of Baiae, with Apollo and the Sibyl* 1823
Oil on canvas
145.5 × 239
(57¼ × 94⅛)
Tate

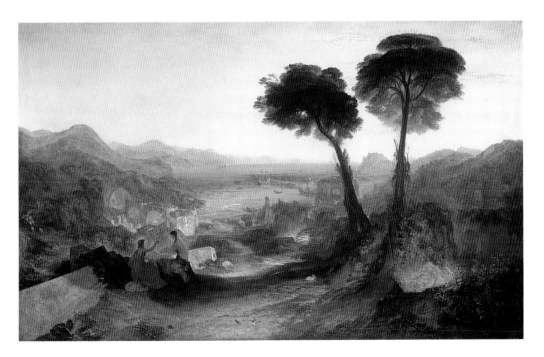

The seriousness of Turner's art, whether demonstrated in his didactic ventures or the increasing complexity of his pictorial narratives, clearly distinguished him from any other landscape artist. His own sense of achievement, perhaps, prompted him to make more overt comparisons with past masters and contemporary rivals, positioning his capabilities against theirs. The titles of some of his pictures invoke variously the Renaissance artists Giovanni Bellini and Raphael, the seventeenth-century Dutch artists Rembrandt, Ruisdael and van Goyen and the eighteenth-century Italian view-painter, Canaletto. We have already noted the stylistic references to Poussin, Claude and Dutch seventeenth-century painting and excursions into the territory of his English contemporary, the genre-painter David Wilkie (1785–1841) also exist.

Watteau Study by Fresnoy's Rules (fig.22) might be understood in the context of these various homages. Turner once declared that 'he had learned more from Watteau than from any other painter'[4] and exhibited two paintings in the 1820s strongly indebted to Watteau's example: *What you Will!* (1822) and *Boccaccio Relating the Tale of the Birdcage* (1828). In *Watteau Study by Fresnoy's Rules*, the French artist Watteau (1684–1721), dressed in eighteenth-century fashion, is shown drawing, with some of his well-known works displayed behind him. The rules alluded to in the title, adopted from Charles Alphonse du Fresnoy's seventeenth-century treatise *De Arte Graphica*, relate to the ways in which colours may appear to advance or recede. White next to black will come forward, white on its own will move back. Turner's painting puts this principle to the test, assessing the quality of du Fresnoy's observations in practice. Watteau's positioning also obeys one of du Fresnoy's precepts, that the most important character be placed at the centre of a composition.[5]

22 *Watteau Study by Fresnoy's Rules* 1831
Oil on oak panel
40 × 69.5
(15¾ × 27⅜)
Tate

Always conscious of the debt a modern artist must pay to his antecedents, Turner exhibited *Rome, from the Vatican. Raffaelle, Accompanied by La Fornarina, Preparing his Pictures for the Decoration of the Loggia* (fig.23) on the three-hundredth anniversary of Raphael's death. The picture was based on Turner's first trip to Italy and provides a complex viewing experience, clearly indebted to his Perspective lectures, with an exceptionally wide and divergent field of vision. Raphael's achievements were well respected in the early nineteenth century and various actual or possible pictures are positioned on a balcony leading off the decorative loggia he also designed. Raphael's example, as a wide-ranging painter and architectural designer, would have appealed to Turner whose own ambitions were similarly expansive. By showing one of the greatest artists of the Renaissance in a deliberately anachronistic setting, Turner may have intended to allude to the universal quality of great art as a distillation of experience. A still life in the left foreground is transmuted into the climbing tendrils of the wall design above it, a landscape painting leads the eye upwards to the distant prospect of the Apeninnes, architectural designs converse with actual buildings, even La Fornarina, Raphael's mistress, is transmogrified into the Madonna. Raphael's contemplation of his own achievement is thus a recognition of the powers of artistic invention, creating rather than slavishly imitating the world.

The lessons of the past implied a respect for the act of painting and the advancement of its potential as a bearer of meaning. Turner's growing insight into the effects of painting brought about changes in technique which reconstituted the spectator's relationship with the painted surface. Much of the critical disquiet which marked his maturity can be explained as resistance to his new language of forms, using painted marks which did not denote their subjects in any straightforward way, and his liberation of colour to become an

24 *The Fall of an Avalanche in the Grisons* 1810
Oil on canvas
90 × 120
(35⅞ × 47¼)
Tate

expressive vehicle, above and beyond its descriptive function. Three examples from the opening decades of the nineteenth century will help explain this.

The Fall of an Avalanche in the Grisons (fig.24) is obviously indebted to Turner's 1802 Swiss tour. Although it is unknown whether he had actually visited the Grisons on that occasion, he was probably later aware of the destructive avalanche there in 1808 which killed many victims. Here, a mountain hut is pulverised by the great mass of snow and rock crashing down on it, alluded to in Turner's accompanying verses: 'extinction follows / And the toil, the hope of man – o'erwhelms.' The picture's surface is heavily worked, especially visible in the use of a palette knife to depict the snow and ice cascading down from the right, as though Turner wanted to convey something of the destructive power of the avalanche by physical means, rendering snow as a heavy, material force, rather than the spectacular but more theatrical avalanches painted by artists like his immediate predecessor de Loutherbourg. In this way, the spectator's space is invaded by the power of the avalanche, infringing the safe distance between the spectacle and the vantage point normally employed in paintings of sublime events.

This erosion of distance, placing the spectator close to rather than outside the phenomenon, is seen again in *Hannibal* (fig.18). This painting is one of the earliest to make use of a vortex in the composition, rotating pictorial energies

around a centrifugal point. At a stroke, this device mobilises the composition to produce dynamic effects that a more classical organisation of space could not incorporate. The sense of a spiralling movement in and out of depth retains the feeling of spaciousness found in more static compositions, but it also allows the interaction of distance with foreground, pulling the light source forward to become part of what it illuminates. As Turner noted, preparing his Perspective lectures, when it came to the impact of light on objects: 'we must consider every part as receiving and emitting rays to every surrounding surface, object, form and plane.'[6] Turner was very aware that this new orchestration of pictorial space needed careful placement in the exhibition rooms at the Royal Academy and went to some trouble to hang the picture lower than normal, to maximise the impact of the vortex on the spectator.

Ulysses Deriding Polyphemus (fig.25), like *Hannibal*, requires a response to its narrative within a formal arrangement which is itself constitutive of meaning, although here it is Turner's use of colour that is pre-eminent. The painting uses Homer's *Odyssey*, in the translation of Alexander Pope, as its source, often sticking closely to the text, but Turner embellishes the classical account with further natural observations and symbolic connotations. The Nereids playing like dolphins at the prow of the ship may owe their appearance to recent investigations into marine phosphorescence, thereby rationalising the supernatural; the horses of Apollo, the sun-god, are visible to the right of the rising sun, as though making the same natural–symbolic point. Polyphemus, the blinded Cyclops from whose clutches Ulysses and his companions escape,

25 *Ulysses Deriding Polyphemus – Homer's Odyssey*
1829
Oil on canvas
132.5 × 203
(52⅛ × 79⅞)
National Gallery, London

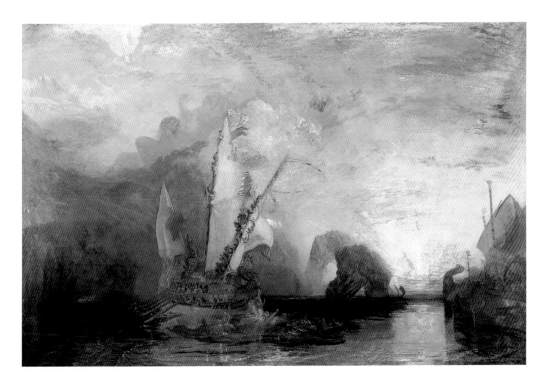

seems to meld into the smoke rolling over the mountain, so making actual the traditional association of the Cyclops with volcanic activity.[7] All of these details are infused with a chromatic intensity which gives a jewel-like quality to the painting, saturating the image with colours which are descriptive and yet something more than that, transposing naturalistic features into another register, such that colour begins to carry the composition and to provide the emotional tone. The contrast between light and darkness reinforces Ulysses' triumph over Polyphemus' pain, while the overall gorgeousness of colour might be said to function like the rhetorical devices of heroic myth, using heightened effects to convey an elemental truth.

4

PICTURING BRITAIN

It is fair to argue that from the outset of his career Turner had understood the importance of disseminating his work via engravings. A growing proportion of his production of watercolours was occasioned precisely for reproduction as monochrome prints, beginning with work produced for the *Copper-Plate Magazine* and similar publications in the mid-1790s. Antiquarian and topographical designs followed up to the mid-1810s, with extensive series devoted to English landscape from the 1810s through to the 1830s, foreign landscapes in the 1830s and literary illustrations in the 1820s and 1830s. This immense body of work amounts to over 600 designs produced for engraving between 1794 and 1840, the bulk of it emerging in the twenty years following the mid-1810s.[1]

From at least the 1810s Turner took an exceptional interest in the production of these engravings, overseeing their production and recommending alterations to the image as proofs were pulled. He was clear that engravings, being produced by means of lines and using only tone, rather than colour, were translations of paintings, which translations meant that 'lines become the language of colours'.[2] To achieve this possibility, Turner virtually trained a new school of landscape engravers in England, whose understanding of his demands took the technical procedures of reproductive engraving to new heights.

The disintegration of the Peace of Amiens and the resumption of hostilities meant that Turner's 1802 trip to France and Switzerland would be his last continental excursion until 1817. As in the 1790s, domestic tourism would have to supply the raw material for landscape painting, and the mainstay of Turner's production in watercolours from the next three decades was the provision of material for publications of British topography. He produced extensive series of watercolours for W.B. Cooke's *Picturesque Views on the Southern Coast of England* (1814–26), Thomas Whitaker's *History of Richmondshire* (1818–23) and Charles Heath's *Picturesque Views in England and Wales* (1827–38), among others.

From a technical point of view, an important development, probably originating in the 1810s, was Turner's consistent use of so-called 'colour beginnings' to establish these compositions in terms of tone and colour.[3] When working up watercolours he is known to have worked in batches, characteristically completing several at once, as noted by one witness who saw him working in sequence on four compositions simultaneously, starting with a lay-in of colour and then bringing each to completion by stages. This seems to have been the procedure noted by Walter Fawkes's children in 1816 who remembered 'cords spread across the room as in that of a washer woman, and

papers tinted with pink and blue and yellow hanging on them to dry'.[4] *The Bass Rock*, one of twelve designs for engraving as illustrations to Walter Scott's *Provincial Antiquities of Scotland*, is illustrated here as colour beginning and finished watercolour, to show the relationship between them (figs.26, 27).

Characteristically, Turner's use of these commissions took topography into a new arena, concentrating as much on contemporary life and local customs as the ruined abbeys and castles or notable scenery that other series tended to

26 *The Bass Rock*
*c.*1824
Watercolour
15.9 × 25.4
(6¼ × 10)
Lady Lever Art
Gallery, Port
Sunlight

27 *The Bass Rock*
*c.*1824
'Colour beginning'
watercolour
21.9 × 29.3
(8⅝ × 11½)
Tate

explore exclusively. His watercolour of *Leeds* (fig.28) is a good example of Turner's comprehensive understanding of location in his topography. In British art of this period, this is a rare example of the depiction of an industrial town, in which the economy of Leeds is made manifest. Turner made the drawings on which this watercolour is based in 1816, when he was touring Yorkshire on commission for designs to illustrate the Reverend T.D. Whitaker's *Richmondshire*, an antiquarian survey, which prompted Turner to produce some of his most magnificent drawings of English landscape, as seen for example in *Wycliffe, near Rokeby* (fig.46). Whitaker was an arch conservative who deplored the impact of industrialisation on the English landscape and worried about its threat to the social fabric. As an antiquarian whose position in society was buttressed by a traditional class hierarchy, he preferred to deal with scenic beauties and the relics of past ages, although, as we shall see, in *Wycliffe* Turner seems to have intended political comment.

Leeds, in contrast, is a resolutely urban and modern image. Turner may have intended it for Whitaker's forthcoming work on Yorkshire, *Loidis and Elmete*, but Whitaker was hardly likely to endorse this celebration of contemporary industry and the book appeared without it. The workmen who occupy the foreground are all accurately studied: tentermen hanging cloth to dry, masons mending a wall, clothworkers carrying finished cloth from the workshops shown at the bottom of the hill, a milk-boy on a pony. Smoking factory chimneys dominate the background of the picture, which might be understood as a depiction of economic prosperity reliant on new industrial

28 *Leeds* 1816
Watercolour
29.2 × 43.2
(11½ × 17)
Yale Center for
British Art, Paul
Mellon Collection

processes and the entrepreneurial skills of a rising middle class. Turner probably knew John Dyer's poem *The Fleece* (1757), included in an anthology of English poetry he owned, which hymned British economic improvements and compared contemporary prosperity to the fate of ancient cities like Carthage whose luxury had ruined them.[5] This was a theme to which Turner would return.

In his watercolour of *Dartmouth Cove with Sailor's Wedding* (fig.29) the same searching attitude to topography is evident. Designed for Heath's *Picturesque Views in England and Wales*, it concentrates more on the rumbustious sailors and their girls than on the conventionally picturesque estuary of the river Dart behind them or Dartmouth Castle in the distance. Yet the image is more informative, when attended to, than conventional topography. Turner visited Dartmouth in the early 1810s, when its deep anchorage was strategically useful in the war effort, so the sailors are rightly prominent. Their activities make sense as a record of a recently paid-off crew enjoying their shore-leave to the maximum. Dartmouth, like Leeds, is thus not only a place with a history, as conventional topography would have it, but a social and economic community whose identity is best explained by depicting its contemporary life.

We can get some measure of the infinite pains Turner was prepared to take over his pictures by considering his *View of the High Street, Oxford*, exhibited in 1810 (fig.30). This oil painting was a commission from the Oxford picture dealer, James Wyatt, who intended to have it engraved, and Turner discussed

29 *Dartmouth Cove with Sailor's Wedding*
*c.*1826
Watercolour
28 × 38.7
(11 × 15¼)
Private Collection

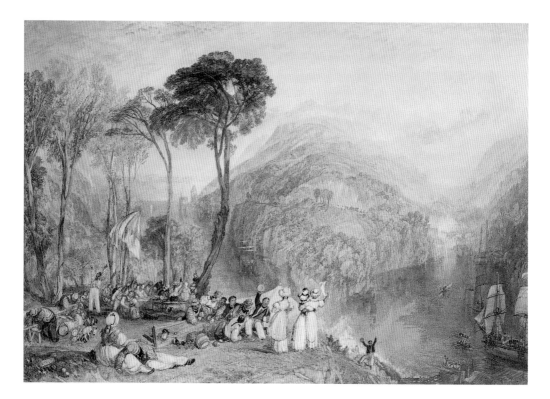

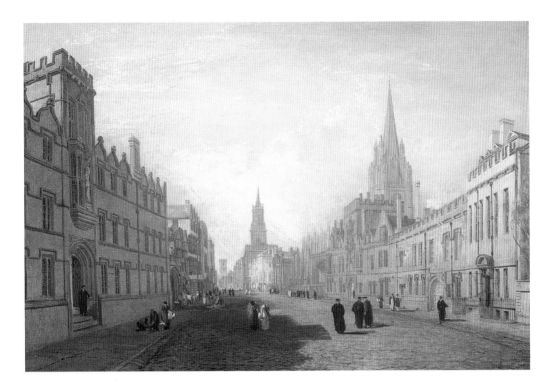

30 *View of the High Street, Oxford* 1810
Oil on canvas
68.5 × 100.3
(27 × 39½)
The Loyd Collection

details of the architecture and figures with him as the picture progressed. A letter from Turner in February 1810 asks Wyatt, 'is it right or wrong to introduce the Bishop crossing the street in conversation with his robes, whether he should wear a cap? what kind of staff the Beadles use, and if they wear caps'; another, a month later, talks about ancillary figures introduced for formal and explanatory reasons: '... I took the hint for the sake of color, to introduce some Ladies. The figures taking down the old Houses are not only admissible but I think explains their loss and the removal of the gateway.'[6]

Turner's exemplary accuracy in matters of dress and occupation might be viewed as an extension of a more widespread tendency towards precise observation at this period. The early years of the nineteenth century saw the development of naturalism as a foundation for British landscape painting, replacing ideal or idealised scenes with a much more self-conscious reliance on visual truth. This attitude inspired artists like John Constable to make faithful transcripts of routine locales, paying scrupulous attention to particularities of weather and the agricultural scene. Although working from the motif was not new in itself, growing numbers of artists made oil sketches in the open air, using a medium traditionally reserved for exhibited pictures more freely and spontaneously to capture nuances of light and colour. Turner, too, made studies from nature and worked in oils from the motif on a number of occasions from the early 1800s, most notably on the Thames and in Devon. Some thirty-five oil studies of the Thames and the Wey were produced *c*.1805–7. Seventeen of them are on canvas and may have been at least begun on the

spot; a second group of eighteen smaller oils, painted on mahogany veneer, were probably produced entirely out of doors (fig. 31). According to a contemporary, Turner painted these Thames studies from his own boat, which would have allowed him to cope with the more cumbersome nature of the operation while yet remaining mobile. The oil sketches produced around Plymouth were produced on Turner's second trip to Devon in the summer of 1813 (fig. 32). Fifteen of them survive, more uniform in size and less wide-ranging in subject than the Thames sketches, lacking, too, something of their brio and spontaneity. Their origins are well-recorded in two contemporary accounts which suggest that Turner undertook this campaign because a local landscape painter, A.B. Johns, had prepared special equipment for outdoor oil-sketching.

In general, however, Turner was as reluctant to paint from the motif in oil

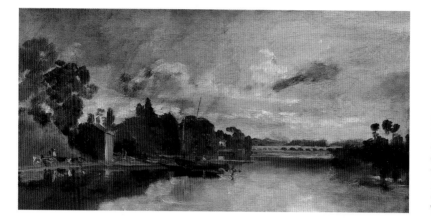

31 *The Thames near Walton Bridges* *c.*1805 Oil on mahogany veneer 37 × 73.5 (14½ × 28⅞) Tate

32 *A Bridge with a Cottage and Trees Beyond* 1813 Oil over black chalk on prepared paper 15 × 23.5 (5⅞ × 9¼) Tate

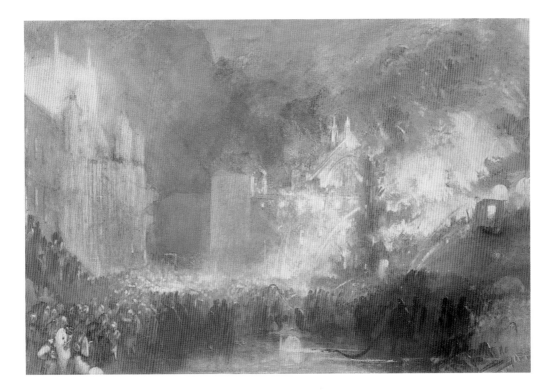

as he was in watercolour, even if eye-witness reports and actual examples suggest a limited occurrence of such activities into the 1840s. He had learned to train his visual memory such that the discipline of observation obviated the need for colour sketching. As early as 1809, in one of his annotations to the *Lectures* of the painter John Opie, Turner wrote: 'Every glance is a glance for study, contemplating and defining qualities and causes, effects and incidents, and develops by practice the possibility of attaining what appears mysterious upon principle.'[7] For these reasons, the traditional story that he made colour sketches of the burning of the Houses of Parliament is probably untrue. Turner is reported as witnessing the events of 16 October 1834, and he exhibited two oil paintings of the fire in the following year. The nine coloured sketches, which seem to record the fire, and a more finished study which is definitely of it (fig.33) have led some commentators to assume that he made coloured sketches on the spot. The spontaneity of the brushwork is, however, of a piece with Turner's characteristic working methods in the studio, as one idea generated another, and the entire sequence may be better understood as experiments in pictorial organisation.

As well as the two oils, Turner also produced a finished watercolour of the Westminster fire, which was published in *The Keepsake* for 1836–7, along with three further images, all of them echoing the idea of destruction by fire or water, man-made or natural catastrophe (fig.34). The tonal contrast and concentration of effect in these vignettes is striking. Because the image has no

34 H. Griffiths after
J.M.W. Turner *The
Wreck*
Line engraving from
The Keepsake, 1836–7
Tate

border, there is a strong sense of centrifugal expansion of energy from the explosive centre out into the whiteness of the page. Even when the subject matter of Turner's vignettes is less dramatic, there is a sense of light welling up from the image to flood the page, concentrating in one small monochrome engraving much of the power seen in his contemporary oil paintings.

Turner's activities as a designer of book illustrations were extensive, producing nearly 150 literary vignettes in the 1830s, but they are perhaps the least well-known of his works today. In the nineteenth century, however, his work reached a very wide audience by this means; by 1847, for example, the two volumes of Samuel Rogers's *Italy* and *Poems*, illustrated by Turner, had sold over 50,000 copies. We have already noticed Turner's employment of verse, whether his own or that of established poets, when exhibiting work, as well as his involvement with reproductive engraving. The work he produced in the 1830s to illustrate the poetry of Samuel Rogers, Sir Walter Scott and Thomas Campbell fused both of these interests to produce some of his most original contributions to engraving.[8]

5

THE FASCINATION OF EUROPE

Turner's continental travels were largely a thing of the late 1810s and afterwards. As we have seen, the French wars had restricted travel abroad during his youth and only in 1802, following the Peace of Amiens, had he been able to visit Paris and travel on to Switzerland. It would be another fifteen years, by which time he was in his early forties, before he left England again. A four-week tour of the Netherlands and the Rhine in 1817 marked the resumption of his foreign excursions, followed by a seven-month trip to Italy in 1819–20. Further travels included nine visits to France and five tours of the Low Countries and Germany between the 1820s and the 1840s, a trip down the Danube to Vienna in 1833, including a brief visit to Venice, two further excursions to Italy in 1828–9 and, Venice only, in 1840, and five more sketching campaigns in Switzerland from 1836 to 1844. After 1845, when he made his final French tour, aged seventy, old age and infirmity kept him at home, but his voracious appetite for travel had by then far exceeded the explorations of foreign countries undertaken by his contemporaries.

Turner was born too late to enjoy the eighteenth century's patronage of artists abroad, either as companions on the Grand Tour or to complete their studies in Italy, although the Earl of Elgin's invitation to Constantinople in 1799 would have given him a taste of it and his 1802 tour was underwritten by Lord Yarborough and two other noblemen to help his artistic education. His travels from 1817 were independent affairs which had, at least, the advantage of beholding him to no one. His sketches record sights that any artist might be expected to take in but they also include studies of people, costumes and equipment, modes of transport, effects of light, and varieties of landscape. This more inclusive understanding is also found in the tourist guides of the time, but few contemporary artists felt equipped to incorporate such varied apprehensions of a place in their work.

Turner's most original tour, in 1835, was through Denmark and south to Prague; otherwise he seems to have had little desire to investigate countries not normally included in the Grand Tour or to explore those places becoming artistically fashionable in the 1830s and 1840s: Spain, the Holy Land and Asia Minor. Turner's travels are, thus, largely free of that tendency to exoticise the otherness of strange peoples and customs, concentrating his attention instead on the everyday life of European countries whose cultures he explored without the condescension so typical of many Victorian painters' witness.

Turner's tour of Belgium and the Rhineland in 1817 produced a variety of work in different media, most notably a series of fifty-one gouache and watercolour drawings of the Rhine (fig. 35). Long believed to have been painted on the spot, they are now accepted as studio productions which Turner made on

35 *The Lorelei* 1817 Watercolour and bodycolour 19.7 × 30.5 (7¾ × 12)
Whitworth Art Gallery, University of Manchester

36 *The Mosel Bridge at Coblenz: sample study* c.1841–2
Watercolour 23.6 × 29.5 (9¼ × 11⅝) Tate

his return. Their sketch-like appearance looks forward to the gouaches he produced in the 1820s and 1830s and, like them, demonstrates that the transition from study to finished work now occupied a narrower interval. That said, these Rhine drawings might be regarded as ambiguously situated in that gap. Although Turner sold this set to Fawkes in 1817, implying they were fully realised, when he produced other Rhine subjects the new watercolours showed more precision, lacking the effect of spontaneous record seen in the 1817 set. Perhaps Fawkes, as an intimate friend, was afforded privileged access to work which Turner would not normally have offered for sale. If so, the Rhine drawings anticipate developments in the 1840s when Turner produced a number of 'samples', worked up from Swiss sketches, to attract interest in a planned series of finished watercolours (fig.36). These samples, together with some finished watercolours, were given to his agent Thomas Griffith to demonstrate to potential purchasers how each sample would become fully developed. It was in such transactions that a few of Turner's contemporaries got to see the private, formative elements of his art.

Turner's first visit to Italy, in 1819, was essentially a fact-finding tour, confirming an interest in its art and architecture that had been nurtured from at least as far back as his patronage by Colt Hoare in the 1790s. His paintings had already tackled classical themes with such atmospheric conviction that some saw Italy through his eyes. His long-standing supporter, the portrait painter Sir Thomas Lawrence (1769–1830) wrote to Farington in 1819: 'Turner should come to Rome. His Genius would here be supplied with new Materials, and entirely congenial with it. It is one proof of its influence on my mind, that ... whenever I go out ... I am perpetually reminded of his Pencil; and feel the sincerest regret that his Powers should not be excited to their utmost force'.[1] For his part, as he neared Rome Turner invoked the names of Claude and Wilson in his sketchbooks, especially with regard to the colour of the Roman Campagna.

37 *View of Naples with Vesuvius in the distance* 1819
Pencil and watercolour
25.5 × 40.5
(10 × 16)
Tate

38 *Forum Romanum,
for Mr Soane's
Museum* 1826
Oil on canvas
145.5 × 237.5
(57¼ × 93½)
Tate

As elsewhere, Turner made use of small sketch-books for pencil sketches when on the move, employing a larger format when based in one place. Some of these larger Italian sketches may have been coloured in the open air, although the eye-witness evidence for such activity is not entirely reliable. What is clear, as this study of Vesuvius reveals (fig.37), is that the intensity of a Mediterranean light was of importance to him and that a colour record, even if completed away from the motif, was essential.

Forum Romanum (fig.38), painted for the architect John Soane, is one of three major paintings which resulted from the first trip to Italy, the others being *Bay of Baiae* and *Rome from the Vatican* (figs.21, 23). Like them, it distils the essence of Turner's experiences in Italy, especially its ancient architecture. The Arch of Titus dominates the middle ground, with the Forum beyond, and the right of the composition shows the Basilica of Constantine. Amidst the relics of this magnificence, a church procession winds into the distance, pious women kneeling as the clerics pass by. This is a deliberately distorted composition, combining different viewpoints, which reaches out beyond topography to meditate on history. Turner alludes to the continuities, much discussed in his day, between paganism and Catholicism, where temples might become churches and Christian ritual adapt aspects of pagan worship.

This willingness to manipulate a location for effect is found again in *Harbour of Dieppe (Changement de Domicile)* (fig.39), a painting derived from sketches made on a quick visit to France in 1824. Although a northern port, Turner's use of colour gives Dieppe an almost Mediterranean appearance and contemporary critics were quick to attack it for its departure from nature. The naturalism of Turner's work in the previous decade was increasingly giving

ground to effects of pictorial harmony whose authenticity in actual appearances was dubious. If the 'splendide mendax' of the *Bay of Baiae* was becoming more general, Turner's critics needed to find a more appropriate language to record their observations. Those not entirely opposed to his development relied increasingly on describing his pictures as offering a 'poetic' rather than a literal truth.

Others were less accommodating. Sir George Beaumont, a patron and influential connoisseur, had attacked Turner with increasing vehemence from the 1800s, especially as regards his luxuriant colour and indistinct forms, and his criticism in the 1810s may have affected sales of Turner's work. Art critics were divided, but hostile reviews dwelt increasingly on the 'viciousness' of Turner's practice, the extravagance of his colour, the coarseness of his paint application, the lack of decorum in his work. The paintings Turner painted in the 1830s provoked a good deal of knocking copy. Famously, the Reverend John Eagles, a critic and amateur artist, attacked Turner's *Juliet and her Nurse* (fig.40) in a review for *Blackwood's Magazine*. The picture is described as 'a strange jumble ... thrown higgledy-piggledly together, streaked blue and pink and thrown into a flour-tub',[2] and it was this criticism that provoked John Ruskin, then only seventeen, to write to *Blackwood's* in Turner's defence. Turner dissuaded him from responding: 'I never move in these matters. They

39 *Harbour of Dieppe (Changement de Domicile)* 1825
Oil on canvas
173.7 × 225.4
(68⅜ × 88¾)
Frick Collection, New York

40 George Hollis
(1793–1842)
*St Mark's Place,
Venice (Moonlight)*
1842
after J.M.W. Turner,
Juliet and her Nurse
1836
Open etching
41.9 × 56.5
(16½ × 22¼)
Tate

are of no import save mischief.'³ Yet it is evident from those who knew him that criticism could hurt, and the frequent accusations of madness may well have struck a nerve with an artist whose mother had been committed to Bedlam.

From the mid-1820s Turner made increasing use of gouache on coloured paper to record his travels. As before, it is important to remember that these images are typically based on pencil drawings, a product of recollection rather than direct observation. As Turner's art matured, he employed a form of record which was less specific in its intentions, increasingly including the emotional impact of a location as part of the subject matter to be depicted. The balance between topographical exactitude and a more suggestive evocation of place thus tilts towards the latter, especially in the 1820s and afterwards. His use of colour is evidently more ambitious than it had been in the 1810s and the economy of means is striking. As well as studies of Venice (fig.42) and the rivers Meuse and Mosel (fig.41), he produced numerous studies of French rivers for engraving. These last originated when Charles Heath, the publisher of Turner's *England and Wales* series (1827–38), as well as *The Keepsake* (1827 onwards), extended his working association with him to produce a regular publication, *Turner's Annual Tours*, embracing the Loire (1833) and the Seine (1834 and 1835). Although the series was not continued, it is indicative of Heath's understanding of Turner's activities as a tourist that such a title should have been chosen as an inducement to attract sales.

Turner's painting of *Rouen Cathedral* (fig.43), produced for the 1834 publication, is justly famous, not least because it provides a comparison with Monet's later views of the structure in the 1890s, which comparison was already being made in Monet's lifetime. Equally, however, it demonstrates the

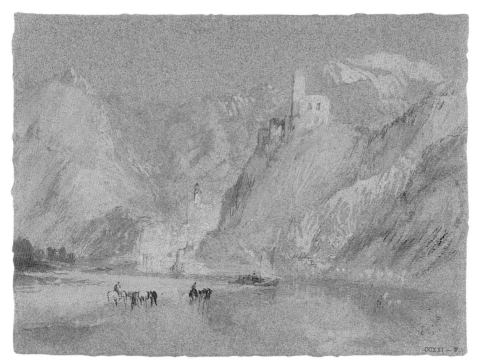

41 *Beilstein and Burg Metternich c.*1839
Watercolour and bodycolour on blue paper 14 × 19.2 (5½ × 7½) Tate

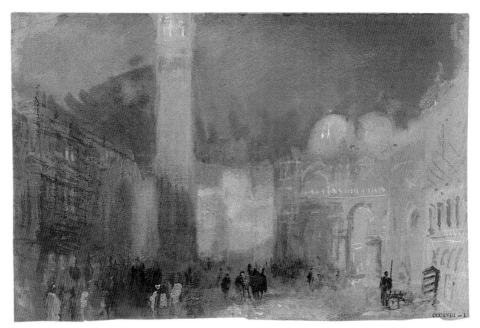

42 *St Mark's from the Piazzetta ?*1840
Watercolour and bodycolour on brown paper 14.9 × 22.7 (5⅞ × 9) Tate

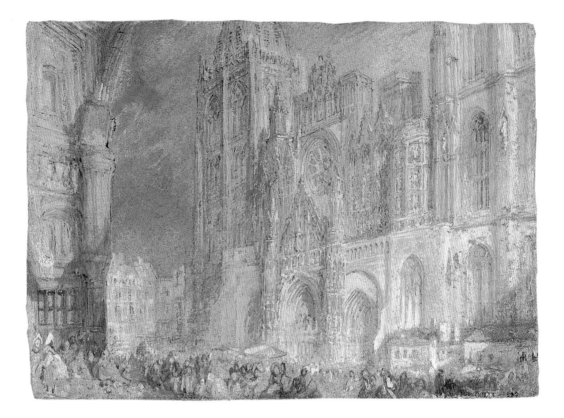

extent to which Turner was prepared to manipulate the actual topography of the location to produce a satisfactory view, as this vantage point, showing so much of the west front all at once, is not obtainable in actual fact. The left and right of the composition are suffused with a golden yellow, offset against the deep blue of the sky, using colour as much as linear perspective to structure the spatial recession of the image. The sense of rich afternoon light provided by the preponderance of gold and deep-toned blue acts as a colour scaffolding for the lilac shadows on the façade of the cathedral, while white highlights on the masonry contrast with the reds and greens in the diminutive crowd of the foreground.[4]

43 *Rouen Cathedral*
*c.*1832
Gouache and
watercolour with
pen on blue paper
14 × 19.4
(5½ × 7⅝)
Tate

6

THE CONTEMPORARY SCENE

We have examined the extent to which Turner made clear his debt to his predecessors, but as a modern artist he was also concerned to produce pictures which incorporated the social, political and intellectual preoccupations of his time. The genesis of *Staffa, Fingal's Cave* (fig.44) might stand as a good example of Turner's scientific interests, combining as it does steam-travel, geology and meteorology. Turner had visited Walter Scott in August 1831, to make sketches of subjects to illustrate Scott's *Poetical Works*. On the return leg of his trip, he travelled by steamer to Oban and Skye and boarded another to explore Staffa and Iona. He drew the geologically significant interior of Fingal's Cave on Staffa, later engraved as the frontispiece to Scott's *Lord of the Isles*, but the trip to Iona was abandoned due to bad weather. Turner shows his steamer off Staffa, its smoke-trail indicating the force of the rising wind and the halo around the setting sun presaging rain. He may have discussed this meteorological effect with Sir David Brewster, an Edinburgh physician he met on the trip, who was investigating such phenomena.

It is this picture which occasioned Turner's famous observation on the indistinctness of his paintings. Colonel James Lenox of New York had instructed the artist C.R. Leslie, Constable's biographer, to purchase a Turner for him for £500 and *Staffa* was thus the first of Turner's paintings to reach the

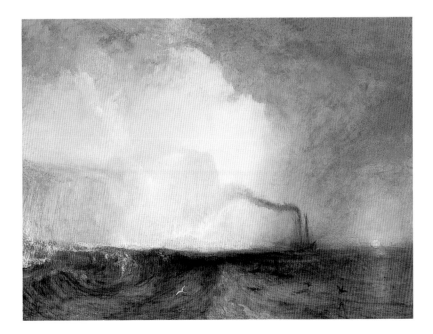

44 *Staffa, Fingal's Cave* 1832
Oil on canvas
91.5 × 122
(36 × 48)
Yale Center for British Art, Paul Mellon Collection

United States. On receipt, however, Lenox thought the picture indistinct, which remark Leslie relayed to Turner. Turner replied that 'indistinctness is my fault' and advised Lenox to wipe the picture with a silk handkerchief.[1] Turner's admission of fault seems to acknowledge that his developing maturity as an artist necessarily required the abandonment of that clarity which had marked his earlier work. Unlike the frequent later misquotation of 'fault' as 'forte', which implies a certain pride in indistinctness, 'fault' is a more measured self-assessment, perhaps alluding to the critical estimation of Turner's work we have already considered. He was aware that the critics' difficulties in making out his pictures were problematic, frustrating any adequate understanding of his intentions. Yet, of course, this indistinctness was not a retreat from precision of observation, nor yet of depiction; Turner's increasingly complex understanding of the observable world required the adoption of a technical procedure capable of dealing with fugitive effects and using formal equivalences to suggest the interconnectedness of discrete phenomena. The 'fault' of indistinctness was thus a necessary and hopefully temporary price to pay until critical understanding matured.

Also painted in the 1830s, *Life-Boat and Manby Apparatus Going off to a Stranded Vessel Making Signal (Blue Lights) of Distress* (fig.45) reveals Turner's fascination with contemporary technology. It depicts a recently developed technique in life-saving, where a mortar fires a lifeline to a stricken vessel. The girl in the foreground appears to be praying for the boat's delivery and a lifeboat is battling through the surge and attempting to tow out a line fastened to the anchor on the beach. The juxtaposition of the girl with the anchor suggests perhaps that Turner intended Hope's traditional symbolic representation by an anchor to register in the viewer's mind. Salvation, if it comes,

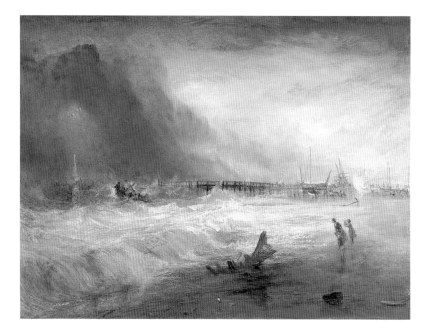

45 *Life-boat and Manby Apparatus Going off to a Stranded Vessel Making Signal (Blue Lights) of Distress* 1831
Oil on canvas
91.4 × 122
(36 × 48)
Victoria and Albert Museum, London

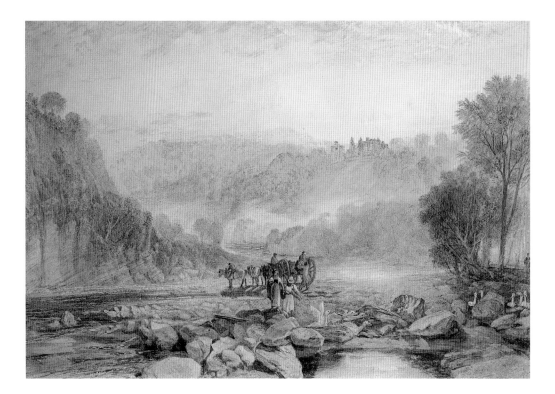

however, is suggested by the events on the horizon, the soaring signal-flare on the left and the puff of smoke from the Manby apparatus on the right. The ship's ascending rocket is pitched against an extremely ominous sky, the flare's man-made light poignant amidst such darkness. The picture is thus simultaneously a representation of modern technology, with a lengthy title imparting technical information, and a poetic meditation on man's unequal combat with nature.

Turner's politics are not known. His patrons were drawn from a variety of backgrounds, Whig and Tory, progressive and reactionary, aristocratic and, towards the end of his career, commercial or industrial, but those with whom he established relationships tended towards liberalism. Sir John Leicester was a moderate Whig, Lord Egremont was noted for his adoption of modern agricultural practices and his liberality towards the poor, and Walter Fawkes was a Whig of quite radical opinions who championed Parliamentary reform and opposed the war and the infringement of liberties brought about by it. None of this proves that Turner's politics were cast in the same mould, but some of his works from the 1810s to the 1840s suggest a belief in enlightened thought, tolerance and liberalism. As well as the more obvious subjects, to be discussed shortly, seemingly innocuous landscape watercolours contained disguised comments on contemporary politics. Turner once remarked of *Wycliffe, near Rokeby* (fig.46) that the sun rising over Wycliffe's house was symbolic of the light of the Reformation, driving away superstition, and in his original letter-

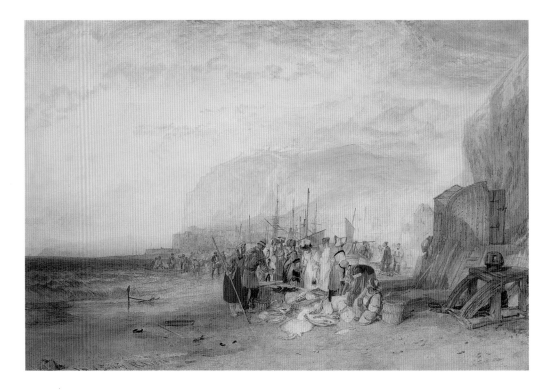

press to the engraving of 1823 he explicitly compared Wycliffe's persecution to recent attacks on freedom of speech in England.[2] *Sidmouth* (*c*.1825) seems to have included a sly attack on the sexual proclivities of Lord Sidmouth, an arch-Conservative who, as Home Secretary, was responsible for politically repressive legislation and was ultimately to blame for the Peterloo massacre. *Stoneyhurst College, Lancashire* (1829) celebrated the Catholic Emancipation Act of that year. The election scene painted in *Northampton* (fig.47) commemorates the return of the progressive Whig Lord Althorp as county member for Northamptonshire in 1830. In the left foreground Turner has included the figure of Marianne, touching the shoulder of an opponent of reform, his tricorn hat indicating his allegiance to past times, to remind him of the recent revolution in France. The intended message must surely be reform or revolution.[3]

Turner's support for the Greeks' liberation from Turkish rule is made evident in two pictures of the temple of Jupiter Panellenius in the island of Aegina, restored and in its actual ruined state (fig.48). Turner knew a number of those associated with the excavation of the temple, begun in 1811, and also appears to have read contemporary investigations of Greek life and culture as well as Byron's references to the Greek cause in the second Canto of *Childe Harold*, published in 1812. Whereas the restored temple is shown at sunrise, it is the setting sun which illuminates the ruins. However, the presence of modern Greeks performing the national dance, together with the inclusion of the Acropolis in the distance, can be regarded as an assertion of cultural integrity which looks forward to a time when Greece will be free again.

47 *Northampton*
1830–1
Watercolour
29.5 × 43.9
(11⅝ × 17¼)
Private Collection

Fish-Market, Hastings (fig.49), produced in 1824, clearly alludes to the Greek War of Independence, then at its height. A standing figure on the left, dressed in Greek national costume, taps a British fisherman on the shoulder as though to remind him of the current struggle; another Greek, arm in a sling, sits at the right of the group. British support for Greek independence was strong, and Byron's personal example of commitment to the struggle was emulated by fund-raising activities in the winter of 1823–4. This watercolour seems to have been intended as a gesture of solidarity with the Greek cause.

Although at first sight merely a picturesque scene of barge traffic, *Nottingham* (fig.51) alludes to the passing of the Great Reform Bill in 1832, leading to the extension of the electoral franchise. The Duke of Newcastle, the owner of Nottingham castle, had evicted tenants who supported parliamentary reform in 1829 and again in 1830, so angering the local population that they attacked and burnt Nottingham castle in October 1831, shortly after the Reform Bill had been defeated in the House of Lords. Turner alludes to this by showing stubble burning below the castle, with a storm clearing off and rainbows in the distance. Once again, he alludes to Greece, showing a Greek flag flying from the mast of one of the barges, thus aligning their fight for freedom with British agitation for Parliamentary reform.

His reaction to Napoleon's campaigns might also be included here. The struggle with France, which dominated Turner's life until he was forty, pre-occupied him to the end of his career, either directly or in classical allusions to the conflict. He visited the battlefield of Waterloo in August 1817 en route to the Rhine, noting details of casualties (the site was included in his tourist's guide to Belgium and Holland). The finished painting (fig.50) shows women-folk searching for their loved ones by torchlight, with the Château of Hougoumont, a key position, still burning on the right and a flare, fired to deter looters, illuminating the rest of the battlefield. The promiscuity of death,

48 *View of the Temple of Jupiter Panellenius, in the Island of Ægina, with the Greek National Dance of the Romaika: the Acropolis of Athens in the Distance. Painted from a sketch taken by H. Gally Knight, Esq. in 1810* 1816
Oil on canvas
118.2 × 178.1
(46½ × 70⅛)
The Duke of Northumberland, K.G.

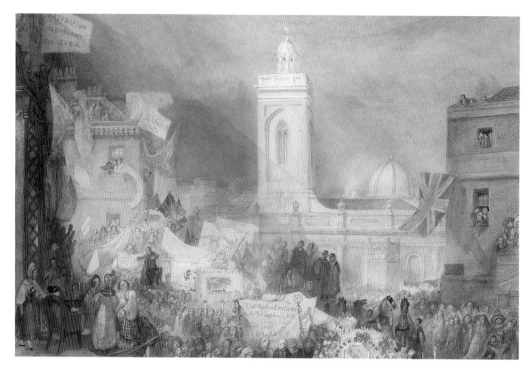

49 *Fish-Market, Hastings* 1824 Watercolour 33.9 × 66.7 (13⅜ × 26¼) Private Collection

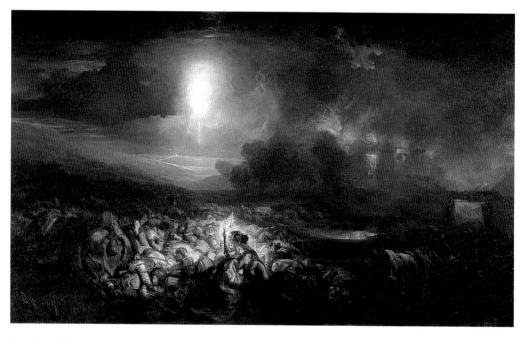

50 *The Field of Waterloo* 1818 Oil on canvas 147.5 × 239 (58⅛ × 94⅛) Tate

with French cavalry and British infantry in a tumbled heap of corpses, is echoed in the lines from Byron's *Childe Harold* Turner used as an accompanying quotation, ending 'rider and horse – friend, foe, in one red burial blent'. Turner's intentions here seem clear, not to celebrate a patriotic victory, but rather to consider the inevitable aftermath of political ambitions as ruthless as Napoleon's.

Turner's patriotism, which prompted him to treat contemporary military success and the growth of democracy and freedom in England, was not narrowly chauvinistic. We can catch a glimpse of his attitude to unthinking patriotism, but also his genuine pride in his country, from a note written in about 1809, looking back to his experience of French art in Paris in 1802: 'Nationality with all her littleness came upon me, but I could not refrain contrasting ourselves to them with advantage.'[4]

Like *Leeds, Keelmen Heaving in Coals by Night* (fig.52) is one of a number of pictures depicting the industrial occupations of England. Turner had already painted watercolour views of *Dudley, Newcastle* and *Shields*, the last of which may have inspired this picture, which explored the nature of a newly industrialised country, finding his subject as much in documentary truth as in explorations of the sublime potential of new manufacturing processes. This painting was commissioned as a companion to one of Venice, painted the year before, expressly to contrast Venice's decline into picturesque impotence with England's industrial energy. The ceaseless activity of Tyneside is thus emphasised by showing fully-rigged ships moving on the Tyne at night and the keelmen working around the clock, the orange flare of their torches contrasted with the silvery moonlight beyond.

As we have seen, the struggle between Rome and Carthage had a particular resonance during the wars with France. The outcome would decide which country was to secure military and economic control of its sphere of influ-

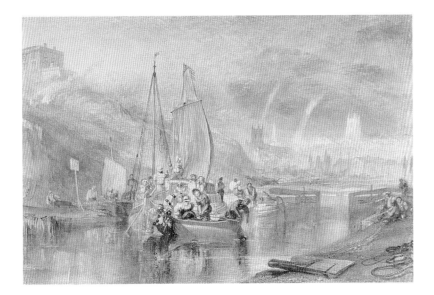

51 *Nottingham, Nottinghamshire*
*c.*1831
Watercolour
30.5 × 46.3
(12 × 18¼)
Castle Museum, Nottingham

ence, with imperial domination a possibility for the victor, impotence and ruin for the vanquished. Turner's view was, typically, more measured. He seems to have considered Carthage's defeat as a warning to any victorious nation that commerce and the pursuit of luxury will eventually enfeeble even the most vigorous state. *The Decline of the Carthaginian Empire* (fig.53), exhibited two years after the Battle of Waterloo, records Carthage's last days as a civilisation, paying the price for its decadence. Turner seems to have intended this to be read as a history lesson, for he provided the picture with an exceptionally long title and accompanied it with verses from *Fallacies of Hope* to make his point:

> At Hope's delusive smile,
> The chieftain's safety and the mother's pride,
> Were to th'insidious conqu'ror's grasp resign'd;
> While o'er the western wave th'ensanguin'd sun,
> In gathering haze a stormy signal spread,
> And set portentous.

Turner was not alone in ascribing Carthage's decline to the evils of commerce and would, for example, have found ample confirmation in his copy of Oliver Goldsmith's *Roman History* (1786), but his holding up of Carthage as a moral lesson to a newly victorious England was unusual. The picture shows at the left Carthaginian hostages being handed over as surety to Roman over-

52 *Keelmen Heaving in Coals by Night*
1835
Oil on canvas
90.2 × 121.9
(35½ × 48)
National Gallery of Art, Washington,
Widener Collection

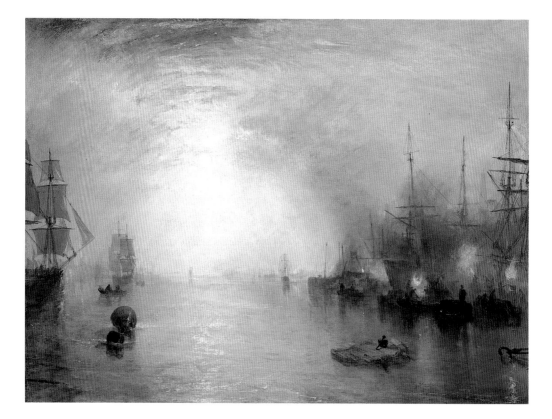

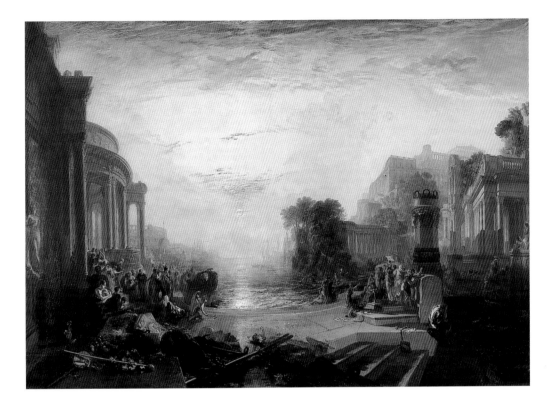

53 *The Decline of the Carthaginian Empire – Rome being determined on the Overthrow of her Hated Rival, demanded from her such Terms as might either force her into War, or ruin her by Compliance: the Enervated Carthaginians, in their Anxiety for Peace, consented to give up even their Arms and their Children* 1817
Oil on canvas
170 × 238.5
(66⅞ × 93⅞)
Tate

seers, one of them imploring against her fate as she is manhandled from the temple. The centre of the foreground is strewn with emblems of Carthage's maritime and commercial wealth while, to the right, a figure in the classical pose of the famous 'Weeping Dacia' muses sorrowfully on the passing of empire.

Turner's liberal sympathies are very much apparent in *Slavers Throwing Overboard the Dead and Dying* (fig.54), a painting which confronts the horrors of the slave trade. Although Britain had abolished slavery in its own territories in 1833, the trade still continued in other parts of the world. Turner drew on a range of sources to inform his subject, but the jettisoning of slaves probably derives from Turner's understanding of the slave trade in its historical and contemporary manifestations. It is likely that he had read Clarkson's *History of the Abolition of the Slave Trade* (1839) which related the actions of the slave ship *Zong* in 1783, whose human cargo suffered an epidemic and whose terms of insurance stipulated that compensation would be paid for those drowned at sea, but not for those dead from disease. The captain's decision to pitch the dead and the dying overboard was thus motivated by commercial greed. This eighteenth-century incident was not, alas, unique; the same callous calculation was made by contemporary slavers who would throw their human cargo overboard when pursued by British ships policing the slave ports.[5] Turner shows the slave ship, close-hauled, awaiting the onset of a typhoon, the sea-

swell already picking up. The verses from *Fallacies of Hope* which accompanied the picture, end with the vicious couplet: 'Hope, Hope, fallacious Hope! / Where is thy market now?' In such a context, the drowning and still shackled slaves are victims of a feeding frenzy which might also symbolise commercial hungers, feeding voraciously off slavery.

We might compare this picture with *Whalers* (fig.55), one of four major depictions of the whaling industry which Turner painted in the 1840s, probably hoping to attract one of his patrons, Elhanan Bicknell, an investor in the Southern Sperm Whale industry. Turner exhibited the first pair at the Royal Academy in 1845, the second a year later. On each occasion the spectator was referred to specific incidents recorded in Thomas Beale's *Natural History of the Sperm Whale*. The companion to this painting illustrates the successful killing of a sperm whale in calm conditions off Japan; here, in contrast, the whalers are exposed to destruction as the whales turn on their tormentors. The chaos of churned-up water, capsizing boats and thrashing tails in the centre of the composition contrasts with the serene motion of the mother ship behind. The silhouette of the mortally stricken whale in the foreground, bleeding from its blow-hole, darkens the sea around it, contrasting with the whaler's white sails. The whaler's spectral presence introduces the shadow of death into the ocean.

54 *Slavers Throwing Overboard the Dead and Dying – Typhon coming on ('The Slave Ship')* 1840
Oil on canvas
90.8 × 122.6
(35¾ × 48¼)
Museum of Fine Arts, Boston

55 *Whalers* 1845
Oil on canvas
91.7 × 122.5
(36⅛ × 48¼)
The Metropolitan
Museum of Art,
Catharine Lorillard
Wolfe Collection,
Wolfe Fund, 1896

7

THE LATE WORK

Light and Colour (Goethe's Theory) – the Morning after the Deluge – Moses Writing the Book of Genesis (fig.56) is one of Turner's most complex paintings, yoking together science and religion. The rainbow, God's sign to Noah after the Flood, is replaced here with prismatic bubbles exhaled from the earth. Indeed, the overall circular composition of the painting, with light welling out from the centre, is itself bubble-like, as though capturing reflections on its spherical surface. Moses, writing the Book of Genesis, sits above the Brazen Serpent, traditionally taken as prefiguring the Crucifixion, with a drowned serpent and other victims piled up below. At first sight then, the painting might seem to offer a vision of optimism, referring to God's covenants to mankind through the agencies of Moses, Noah and Jesus himself.

Turner owned a translation of Goethe's *Fahrbenlehre* which divided colours into two symbolic registers: 'plus' (red, yellow and green), associated with warmth and happiness, and 'minus' (blue, blue-green and purple), associated with anxiety. The painting was first exhibited with a companion, *Shade and Darkness – the Evening of the Deluge* (fig.57), whose palette was organised around Goethe's 'minus' colours. In contrast, the colours used here are 'plus' colours, which ought to support an optimistic reading of the picture, but Turner's appended verses, when he exhibited this painting in 1843, are pessimistic. Each bubble, 'Hope's harbinger', is 'ephemeral as the summer fly / Which rises, flits, expands, and dies'. God's covenant, it seems, is temporary and therefore delusive.

Beyond the symbolic register of the painting, Turner seems to have been concerned to advance the potential of light as a source of sublimity. It is not merely in the conventionally sombre tones of *Shade and Darkness*, but also in the prismatic radiance of *Light and Colour* that sublimity may be experienced. The light, retreating into the distance in *Shade and Darkness*, advances here towards the spectator, suggesting a vision of the ineffable not unlike the glimpses of heaven offered in Baroque ceiling paintings. Here, though, this sublime radiance is produced by natural, not divine light. Beyond the (earthly) delusions of hope lie intimations of transcendence in nature.

The idea that light and colour might have almost a moral force is not directly stated. As we have seen, Turner's symbolism tended towards the use of allusion rather than direct reference. Nevertheless, he did on occasion use symbolic colour, most notably in two works of 1842 dealing with war and peace. *Peace – Burial at Sea* (fig.59) is a tribute to the painter David Wilkie, who died on his return from the Middle East and was buried off Gibraltar on the night of 1 June 1841. The contrast between moonlight and the funereal sails silhouetted against it is evidently symbolic of death (Turner is recorded as

56 *Light and Colour (Goethe's Theory) – the Morning after the Deluge – Moses Writing the Book of Genesis* 1843 Oil on canvas 78.5 × 78.5 (30⅞ × 30⅞) Tate

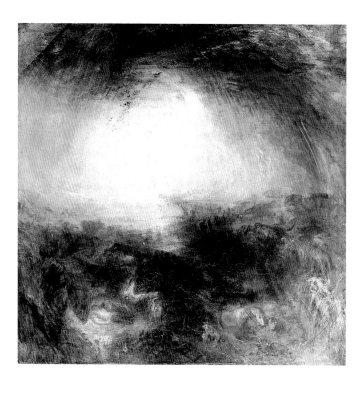

57 *Shade and
Darkness – the
Evening of the Deluge*
1843
Oil on canvas
78.5 × 78
(30⅞ × 30¾)
Tate

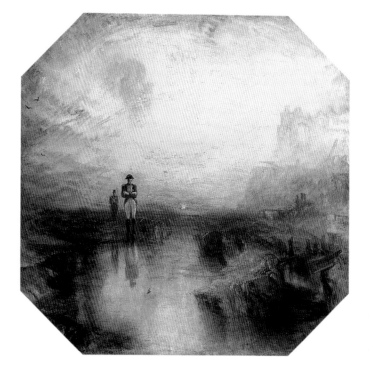

58 *War. The Exile and
the Rock Limpet* 1842
Oil on canvas
79.5 × 79.5
(31¼ × 31¼)
Tate

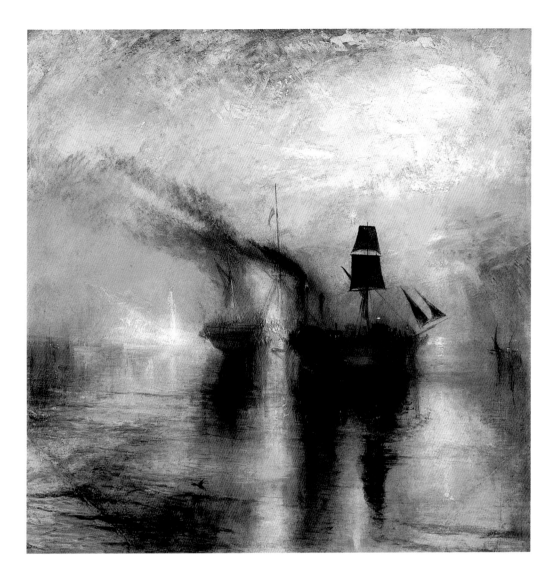

59 *Peace – Burial at Sea* 1842
Oil on canvas
87 × 86.5
(34¼ × 34)
Tate

wishing he could have made the sails blacker still).[1] The picture was first exhibited alongside *War. The Exile and the Rock Limpet* (fig.58), showing Napoleon in exile on St Helena, where red is used to evoke the bloody carnage his ambitions had set in train. This was the picture whose meaning Turner hinted at, but would not explain, to Ruskin. In general terms, however, he seems to have intended the visual similarity of a soldier's bivouac tent to a limpet shell to prompt comparisons between Napoleon's unnatural and involuntary isolation on the 'rock' of St Helena and the limpet's natural colonisation of its rightful habitat.

Evidently, however, the works of Turner's final decade tend towards elliptical and ambiguous meanings which cannot be entirely resolved. At times the mood seems dark. *The Angel standing in the Sun* (fig.60) is taken from the Book

of Revelation, which Turner quoted in the Royal Academy exhibition catalogue:

> And I saw an angel standing in the sun; and he cried with a loud
> voice, saying to all the fowls that fly in the midst of heaven, 'Come and
> gather yourselves together unto the supper of the great God;
> That ye may eat the flesh of kings, and the flesh of captains, and the
> flesh of mighty men, and the flesh of horses, and of them that sit on
> them, both free and bond, both small and great.'

In the centre of the foreground can be seen a chained serpent, referred to in Revelation 20, with figures from the Old Testament close by: Adam and Eve with Cain fleeing from his murder of Abel, Samson and Delilah, and Judith with her maid, who holds aloft the head from the decapitated body of

60 *The Angel standing in the Sun*
1846
Oil on canvas
78.5 × 78.5
(30⅞ × 30⅞)
Tate

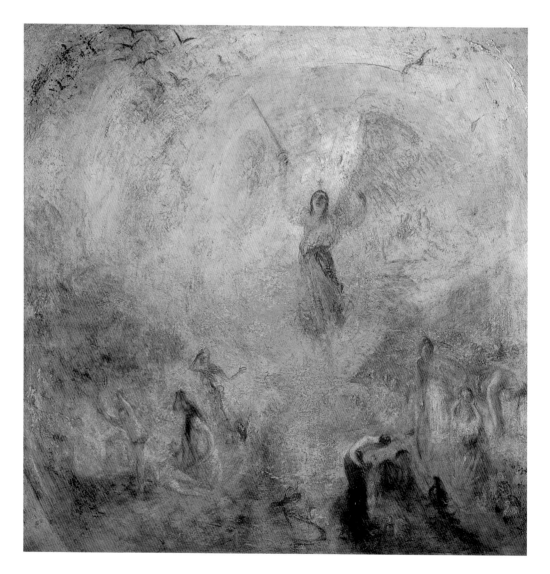

Holofernes. A skeleton repeats Adam's gesture of despair. The angel, placed in the centre of concentric circles of light, seems to drive these figures away, echoing the original expulsion from Eden. In this fallen world, death is omnipresent, aided and abetted by the murders and betrayals that stain the course of human history. It is a pessimistic painting and Turner appended another quotation, from Samuel Rogers's *Voyage of Columbus*, which drives the message home:

> The morning march that flashes to the sun;
> The feast of vultures when the day is done.

As so often with Turner, human optimism and ambition is shown as fallacious and self-deluding. His pessimism at the human condition is at its bleakest here.

Other images do not betray the same impulse, even when they deal with calamity. *Goldau* (fig.61) was worked up from one of the 1843 Swiss watercolours presented as samples and is a notable example of his late watercolour style. The subject refers to a village which was overwhelmed in an avalanche in 1806, whose violence was such as to permanently alter the local landscape. 457 people died. The placid anglers in the foreground suggest, perhaps, a new accommodation with nature, acquiescing in the altered topography of the valley floor and made insignificant by the majestic sunset behind them. This humility in the face of nature may, however, be intended as more than a comment on the aftermath of the 1806 avalanche. Turner was aware of the geologist Grenville Penn's attempts to use the geological record of the Alps as evidence of the biblical flood, and Goldau's destruction had provided important geological data in newly revealed strata. Its obliteration in 1806 might

61 *Goldau* 1843
Watercolour
30.5 × 47
(12 × 18½)
Private Collection

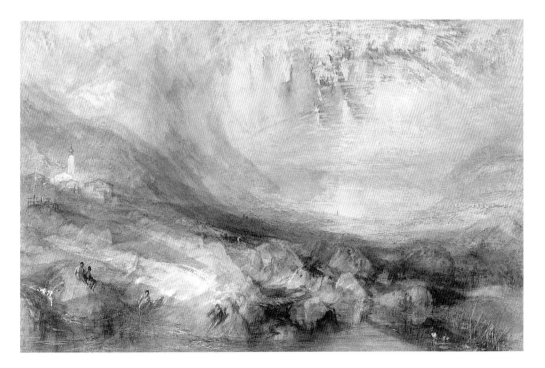

thus be seen as both recapitulating and revealing the universal destruction of the Deluge.[2]

Some other late Swiss watercolours are more tranquil, more concerned to register gradations of light within an extensive spatial envelope. Turner's numerous studies of the Rigi and the three views of it which he included in his 1842 set of Swiss watercolours, allowed him to refine his treatment of the mountain (fig.62). His mature watercolour style combined the most delicate application of washes, together with a minute weave of hatched and stippled colour. Yet colour was not necessarily used naturalistically; instead, Turner seems to have intended a transposition into another key to produce chromatic effects whose resonance excelled nature's. Perhaps there is an echo here of remarks Turner made in a lecture thirty years earlier on Rembrandt's use of chiaroscuro:

> Rembrandt depended upon his chiaroscuro, his burst of light and darkness to be *felt* ... he has thrown that veil of matchless colour, that lucid interval of Morning dawn and dewy light on which the Eye dwells so completely enthrall'd, and it seeks not for its liberty, but as it were, thinks it a sacrilege to pierce the mystic shell of colour in search of form.[3]

It was one of Turner's major achievements to have taken the principle of chiaroscuro, traditionally associated with pictures in which light is contrasted with dramatic shadows, and to use it as a chromatic device in light-toned pictures.

One notable feature of Turner's late style is the extent to which watercolour and oil techniques seem to converge, especially in the unfinished oil paintings found in his studio on his death. In one sense, however, this was not unexpected. As far back as the late 1790s and early 1800s some of his watercolour

62 *The Blue Rigi: Lake of Lucerne – sunrise* 1842
Watercolour
29.7 × 45
(11¾ × 17¾)
Private Collection

63 *Yacht Approaching the Coast* c.1835–40
Oil on canvas
102 × 142
(40⅛ × 55⅞)
Tate

sketches combined coloured grounds with different media, pen, chalk, watercolour and bodycolour, such that one might imagine them developed as finished pictures either in oil or watercolour. Similarly, as early as 1812 Sir George Beaumont had complained that 'Much harm ... has been done by endeavouring to make paintings in oil appear like watercolours, by which in attempting to give lightness & clearness, the force of oil painting has been lost.'[4] We have already examined Turner's lightness of palette in oil paintings, while the gouaches of the 1820s onwards suggest a richness of effect which might as easily have been worked up into oils as watercolours. Finally, Turner's watercolour practice of laying in a composition and returning to it at a later stage finds an echo in his mature practice as an oil painter where canvases might be worked on in series and compositions brought to a finished state on the walls of the Royal Academy or British Institution on Varnishing Days.

Varnishing Days were formally introduced at the Royal Academy in 1809, to regulate a practice which was causing concern by benefiting some artists at others' expense. Three days were allotted to make final adjustments to paintings in respect of the overall lighting of the exhibition space and the work hung adjacent to them. Turner took advantage of this dispensation from early on, but in the 1830s he began to use Varnishing Days as a means of completing paintings which were barely more than lay-ins when originally submitted.

Perhaps modelling himself on the Italian violin virtuoso, Niccolò Paganini, whose London concerts in the early 1830s were the talk of the town, Turner seems to have intended a public demonstration of his prowess, making of painting not a transparent opening on to the world, but a wrought thing, literally conjured into being. The act of creation is thus as much a part of the image as its subject, and the implication must be that Turner was ultimately exhibiting himself, his vision and creative powers, to the public.

In one sense, this extremely personalised approach to exhibition is reflected in Turner's later marine subjects, where the observer–painter seems as much a part of the meaning of the painting as the subject itself. During the 1830s and 1840s he was working on a series of over thirty unexhibited pictures, in which he explored storms, breaking waves and effects of light. Like all of them, *Yacht Approaching the Coast* (fig.63) remains unfinished and its subject matter obscure, but it is more developed than many and provides a good example of Turner's strength of colour in the late 1830s, with spectacular effects of crimson and gold in the centre. His characteristic procedure of placing the sun at the heart of the composition, with radiating diagonals centred on it, organises the composition and controls the spiralling vortex of light, wheeling through the sky. The observation of nature and the formal experimentation seen in works like these undoubtedly helped Turner visualise those marine subjects he exhibited at this period.

One of the most impressive of these is *Snow Storm – Steam-Boat off a Harbour's Mouth Making Signals in Shallow Water, and Going by the Lead* (fig.64). The subtitle to this picture declares, 'The Author was in this Storm on the Night the Ariel left Harwich.' Despite this proclamation of eye-witness observation, modern research has been unable to confirm the events. Turner himself repeated his claim, explaining to one visitor to his gallery that he had been lashed to the mast to observe the storm and did not expect to escape. The story itself may be another of Turner's homages to precedent, recalling a similar story told of the French eighteenth-century painter Joseph Vernet, but, whether literally or figuratively true, it underlines his insistence that disciplined observation underpinned his practice as a painter. Turner's fixity in the midst of the storm raging around him is thus akin to his perception's organising what might otherwise seem merely chaotic. Crucially, however, whereas his eighteenth-century predecessors would have presented a similarly sublime experience by looking on, positioning their viewpoint outside the phenomenon, Turner's ambition was to allow the picture to register the storm from within. The spiralling smoke, surging waves and swirling cloud produce a centrifugal vortex that engulfs the spectator. The powerful motion of the storm is thus reiterated in the dynamism of the picture's surface, in turn mobilising our gaze to echo that movement, circling in gyres around the centrally positioned steamer.

Turner died in December 1851 and was buried in St Paul's Cathedral. He was seventy-six. His work represents such a mass of creative effort, that any attempt to sum it up is frustrated by its range and complexity. In one sense, however, it is necessary that we attempt to come to terms with his achieve-

ment, to keep his example active and alive, as still offering useful lessons to us today. At bottom, Turner's most important legacy was to show how perception is mobile and discriminating, optical but also intellectual, the product of human physiology but also specific to a particular time. More perhaps than any nineteenth-century artist, his work bears full and comprehensive witness to its own cultural situation, to a world changing from one social, political and technological understanding to another.

Turner, as an exemplary modern artist, made his own practice a highly self-conscious, historically aware activity in which the achievement of past and present art is invoked or emulated, whilst at the same time the new culture of the age is addressed as a topic worthy of painting. Equally the language of art itself, its burden of tradition as well as its potential to articulate insights through 'abstract' qualities of light and colour, is foregrounded in Turner's practice as a register of the creative activity. A neutral transcript of nature is always secondary to the work of imagination associated with artistic endeavour. His work is thus not merely an expression of his thought, nor simply a reflection of the times in which it was made, but is instead held at the intersection of those two realms, where the artist engages in a specific cultural situation to record and comment on it. The technical means involved in doing so figure as a trace of that engagement, registering the process by which experience becomes art.

64 *Snow Storm – Steam-Boat off a Harbour's Mouth Making Signals in Shallow Water and Going by the Lead. The Author was in this Storm on the Night the Ariel left Harwich* 1842
Oil on canvas
91.5 × 122
(36 × 48)
Tate

Notes

Chapter One: Turner's Legacy

1 The opening of the Clore Wing at the Tate Gallery in 1987 resulted in the Tate's Turner collection being sequestered there for the next decade. With the reorganisation of the Tate as Tate Britain, however, many of Turner's most significant paintings have been reintegrated into the main galleries.

2 See *Turner: 1775–1851*, London, 1974, pp.172–4.

3 Lawrence Gowing, *Turner: Imagination and Reality*, New York, 1966.

4 *The Morning Chronicle*, 8 May 1844; *Fraser's Magazine*, June 1844, both quoted in Martin Butlin and Evelyn Joll, *The Paintings of J.M.W. Turner*, New Haven and London, rev. edn. 1984, p.257.

5 *The Times*, 8 May 1844, quoted in Butlin and Joll 1984, p.257.

6 Quoted in Walter Thornbury, *The Life and Correspondence of J.M.W. Turner*, 2nd edn., London 1877, pp.368–9.

7 Turner to Jane Fawkes, cited in W.L. Leitch, 'The Early History of Turner's Yorkshire Drawings', *Athenaeum*, 1894, p.327.

8 Constable to Maria Bicknell 30 June 1813, in R.B. Beckett (ed.), *John Constable's Correspondence*, vol.2, Ipswich: Suffolk Records Society, 1964, p.110.

9 F.T. Palgrave to W.M. Rossetti c.1867, cited in G.F. Palgrave, *Francis Turner Palgrave: His Journals and Memoirs of his Life*, London, 1899, p.111. Palgrave had met Turner in 1851.

10 John Ruskin, *Praeterita*, in E.T. Cook and Alexander Wedderburn, *The Works of John Ruskin*, London, 1903–12, 39 vols. vol.35, p.305. As Ian Warrell has noted, the account given in *Praeterita* suggests this is an accurate account of a meeting on 23 June 1840, but it seems to incorporate observations from another encounter on 5 July 1841, both being blended together and embellished for publication. See Ian Warrell, *Through Switzerland with Turner: Ruskin's First Selection from the Turner Bequest*, London, 1995, p.29, n.12.

11 British Library Add. Ms. 46151 H (1818), quoted in John Gage, *Colour in Turner: Poetry and Truth*, London, 1969, p.209.

12 Quoted in Thornbury 1877, p.229.

13 John Ruskin, *Modern Painters*, vol.5, p.435 n., quoted in Thornbury 1877, p.384.

Chapter Two: The Making of an Artist

1 Cook and Wedderburn, *The Works of John Ruskin*, vol.13, pp.298–9.

2 Turner's use of a wide range of sketchbooks throughout his career makes generalisation difficult, and these remarks are intended to offer no more than a guide to his practice. There are, of course, exceptions, with watercolour work occurring in smaller sketchbooks, too. Debate still continues concerning the extent to which Turner produced coloured sketches from the motif and how reliable the evidence for this is.

3 British Library Add. Ms. 46151, AA, quoted in Eric Shanes, *Turner's Human Landscape*, London, 1990, p.245.

4 Diary entry for 16 [17] Nov. 1799 in Kenneth Garlick, Angus Macintyre and Kathryn Cave, *The Diary of Joseph Farington*, New Haven and London, 1978–84, vol.4, p.1303.

5 Diary entry for 5 Jan. 1798 in Garlick, Macintyre and Cave 1978–84, vol.3, p.963.

6 British Library Add. Ms. 46151 K (c.1810), quoted in Shanes 1990, p.74.

7 Note by Turner in his copy of Martin Archer Shee's *Elements of Art*, pp.32–3, quoted in Gage 1969, p.98.

Chapter Three: Painting and Meaning

1 Turner to John Britton Nov. 1811 in John Gage (ed.), *Collected Correspondence of J.M.W. Turner*, Oxford, 1980, pp.50–1.

2 See Gage 1969, pp.137–9.

3 Thornbury 1877, p.103.

4 Turner to William Kingsley, in Cook and Wedderburn, *The Works of John Ruskin*, vol.35, p.601 n. For Watteau's influence on Turner see Selby Whittingham, 'What You Will; or some notes regarding the influence of Watteau on Turner and other British Artists', *Turner Studies*, vol.5, no.1, 1985, pp.2–24 and vol.5, no.2, 1985, pp.28–48.

5 See Cecilia Powell, *Turner in the South: Rome, Naples, Florence*, New Haven and London, 1987, pp.198–9.

6 British Library Add. Ms. 46151 H, c.1811.

7 See Gage 1969, pp.128–32.

Chapter Four: Picturing Britain

1 This figure excludes the 91 designs for the *Liber Studiorum* and engravings after Turner's oil paintings. See Luke Herrmann, *Turner Prints: The Engraved Work of J.M.W. Turner*, Oxford, 1990, pp.260–77.

2 British Library Add. Ms. 46151 A, *c.*1810, quoted in Gage 1969, pp.50 and 196.

3 Some of Turner's earlier studies of the late 1790s perform the same function, so the seeds of this practice were probably sown over a decade earlier than the 1810s. My thanks to Ian Warrell for clarifying this point.

4 See W.L. Leitch, 'The Early History of Turner's Yorkshire Drawings', *Athenaeum*, 1894, p.327.

5 See Stephen Daniels, 'The Implications of Industry: Turner and Leeds', *Turner Studies*, vol.6, no.1, Summer 1986, pp.10–17.

6 Turner to James Wyatt 28 Feb. 1810 and 14 March 1810 in Gage 1980, pp.40–1.

7 Cited in A.J. Finberg, *The Life of J.M.W. Turner, R.A.*, Oxford, 1961, p.230.

8 See Jan Piggott, *Turner's Vignettes*, London, 1993.

Chapter Five: The Fascination of Europe

1 Quoted in Finberg 1961, p.260.

2 Quoted in Butlin and Joll 1984, pp.215–16

3 Turner to John Ruskin 6 Oct. 1836 in Gage 1980, pp.160–1.

4 See Ian Warrell, *Turner on the Seine*, London, 1999, pp.181–6.

Chapter Six: The Contemporary Scene

1 The incident is reported in Butlin and Joll 1984, p.199.

2 See Shanes, *Turner's Human Landscape*, 1990, pp.16–21.

3 These interpretations of Turner's allusive topography are indebted to the detailed work undertaken by Eric Shanes. See especially his *Turner's England, 1810–38*, London, 1990.

4 Turner's annotation to Martin Archer Shee's *Elements of Art*, pp.32–3, quoted in Gage 1969, p.98.

5 See John McCoubrey, 'Turner's Slave Ship: Abolition, Ruskin, and Reception', *Word and Image*, vol.14, no.4, Oct.–Dec. 1998, pp.319–53.

Chapter Seven: The Late Work

1 Thornbury 1877, pp.323–4.

2 For Turner's interest in geology see John Gage, *J.M.W. Turner: A Wonderful Range of Mind*, New Haven and London, 1987, pp.218–22.

3 Quoted in Gage, ibid., p.103.

4 Diary entry for 21 Oct. 1812 in Garlick, Macintyre and Cave 1978–84, vol.12, p.4224.

Bibliography

Bailey, Anthony *Standing in the Sun: A Life of J.M.W. Turner*, London 1997

Brown, David Blayney *Turner and Byron*, London 1992

Brown, David Blayney *Turner in the Alps: 1802*, Lausanne 1998

Butlin, Martin and Joll, Evelyn *The Paintings of J.M.W. Turner*, New Haven and London 1984

Cook, E.T. and Wedderburn, Alexander *The Works of John Ruskin*, London 1903–12

Davies, Maurice *Turner as Professor: The Artist and Linear Perspective*, London 1992

Finberg, A.J. *The Life of J.M.W.Turner, R.A.*, (revised edition) Oxford 1961

Forrester, Gillian *Turner's 'Drawing Book': The Liber Studiorum*, London 1996

Gage, John *Colour in Turner: Poetry and Truth*, London 1969

Gage, John *The Collected Correspondence of J.M.W. Turner*, Oxford 1980

Gage, John *J.M.W. Turner: 'A Wonderful Range of Mind'*, New Haven and London 1987

Gowing, Lawrence *Turner: Imagination and Reality*, New York 1966

Hamilton, James *Turner: A Life*, London 1997

Herrmann, Luke *Turner Prints: The Engraved Work of J.M.W. Turner*, Oxford 1990

Hill, David, Warburton, Stanley and Tussey, Mary *Turner in Yorkshire*, York 1980

Hill, David *Turner in the Alps: The Journey through France and Switzerland in 1802*, London 1992

Lindsay, Jack *J.M.W. Turner: A Critical Biography*, London 1966

Piggott, Jan *Turner's Vignettes*, London 1993

Powell, Cecilia *Turner in the South: Rome, Naples, Florence*, New Haven and London 1987

Powell, Cecilia *Turner's Rivers of Europe: The Rhine, Meuse and Mosel*, London 1991

Powell, Cecilia *Turner in Germany*, London 1995

Royal Academy *Turner, 1775–1851*, London 1974

Shanes, Eric *Turner's England*, London 1990

Shanes, Eric *Turner's Human Landscape*, London 1990

Shanes, Eric *Turner's Watercolour Explorations*, London 1997

Stainton, Lindsay *Turner's Venice*, London 1985

Thornbury, Walter *The Life of J.M.W. Turner*, second edition, London 1877

Warrell, Ian *Through Switzerland with Turner: Ruskin's First Selection from the Turner Bequest*, London 1995

Warrell, Ian *Turner on the Loire*, London 1997

Warrell, Ian *Turner on the Seine*, London 1999

Wilkinson, Gerald *The Sketches of Turner, R.A.*, London 1974

Wilton, Andrew *The Life and Work of J.M.W. Turner*, London 1979

Wilton, Andrew *Turner and the Sublime*, London 1980

Wilton, Andrew *Turner in Wales*, Llandudno 1984

Wilton, Andrew *Turner in his Time*, London 1989

Wilton, Andrew and Turner, Rosalind Mallord *Painting and Poetry: Turner's Verse Book and his Work of 1804–1812*, London 1990

Photographic Credits

Index

Works by Turner are indexed by title; works by other artists are indexed under the artist's name.